M IS FOR MOOSE

A CHARLES PACHTER ALPHABET

Cormorant Books Inc.

M is for Moose: A Charles Pachter Alphabet
Text and Illustrations © Charles Pachter 2008
This edition copyright © Cormorant Books Inc. 2008
Third printing, 2010.

The publisher gratefully acknowledges the support of the
Canada Council for the Arts and the Ontario Arts Council
for its publishing program. We acknowledge the financial
support of the Government of Canada through the Book
Publishing Industry Development Program (BPIDP) for our
publishing activities.

Printed and bound in Canada

Library and Archives Canada Cataloguing in Publication

Pachter, Charles, 1942–
M is for moose: a Charles Pachter alphabet /
Charles Pachter.

ISBN 978-1-897151-33-4

1. English language — Alphabet — Juvenile literature.
2. Alphabet books — Juvenile literature. 3. Canada —
Pictorial works — Juvenile literature. I. Title.

PE1155.P32 2008 J421'.1 C2008-903311-6

Editor: Marc Côté
Cover design: Angel Guerra/Archetype
Cover image: Detail from *Love Pat*, Charles Pachter, 2006
Text design: Tannice Goddard/Soul Oasis Networking
Printer: Manufactured by Friesens Corporation, in Altona,
 MB, Canada in January 2010. Job #48713.

Cormorant Books Inc.
215 Spadina Avenue, Studio 230, Toronto, ON Canada M5T 2C7
www.cormorantbooks.com

The publisher and author would like to acknowledge and thank
Eleanor of Mabel's Fables for her encouragement and guidance.

Mixed Sources
Cert no. SW-COC-001271
© 1996 FSC
FSC

In memory
of Dibbles

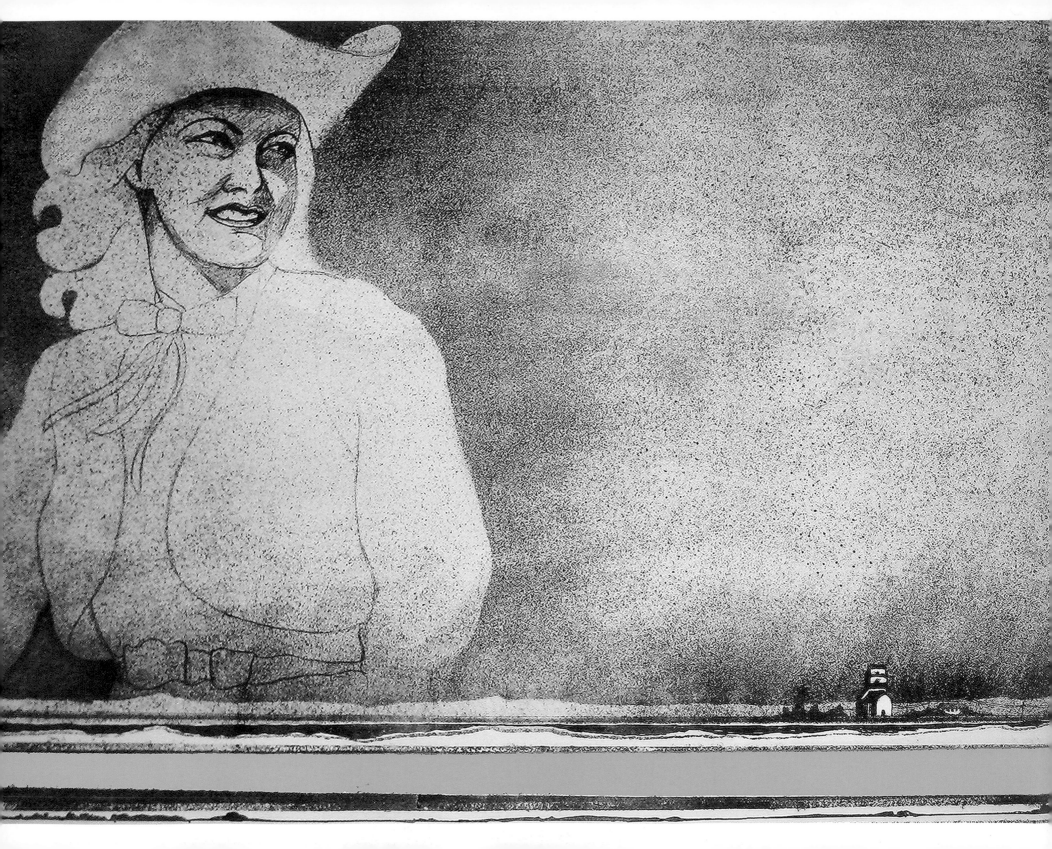

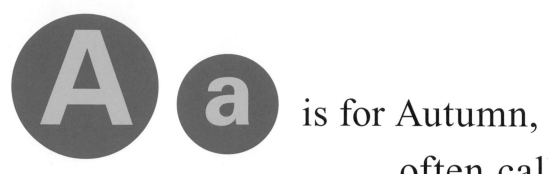 is for Autumn,
often called fall.

A is for
Alberta,
hear the
rodeo call?

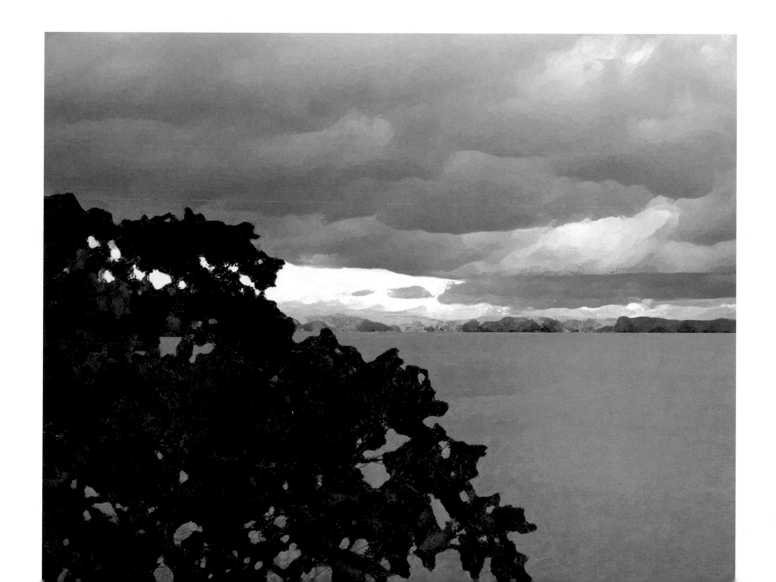

B b

is for
Butter Tarts,

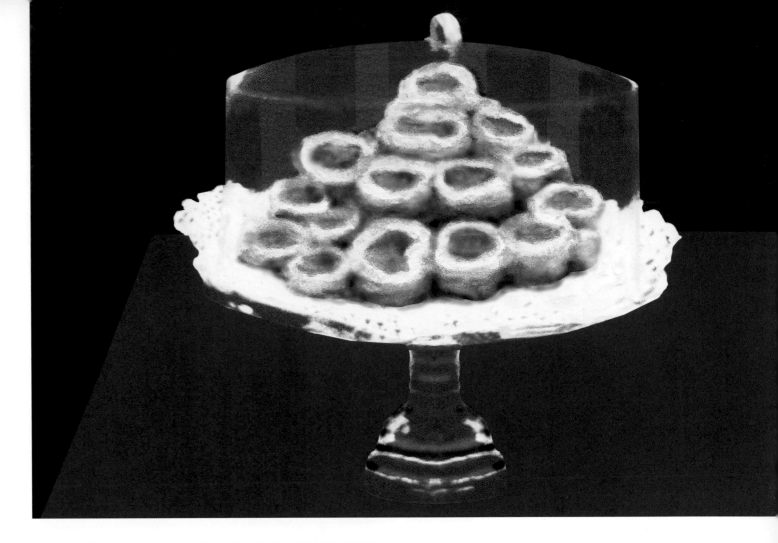

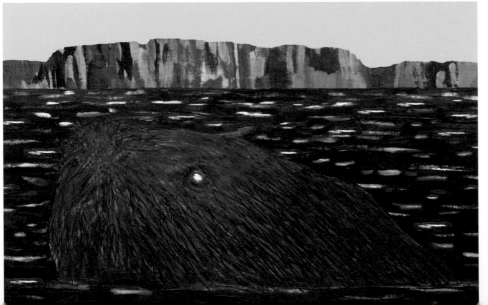

Beaver,

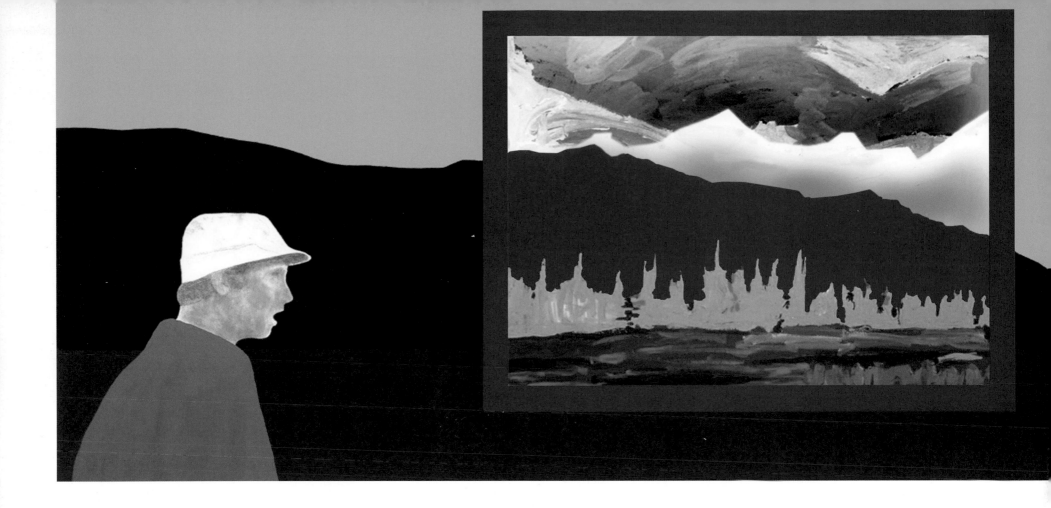

BC, and Barns.

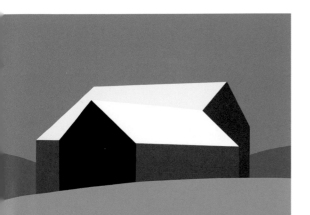

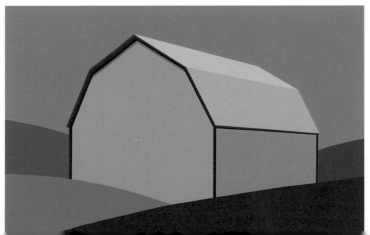

Can you think of four items that make better yarns?

 is for

Castle Frank
and of course

Canoe,

and also ...

Clouds,

and moose Crossing *la rue*.

is for
Ducks,

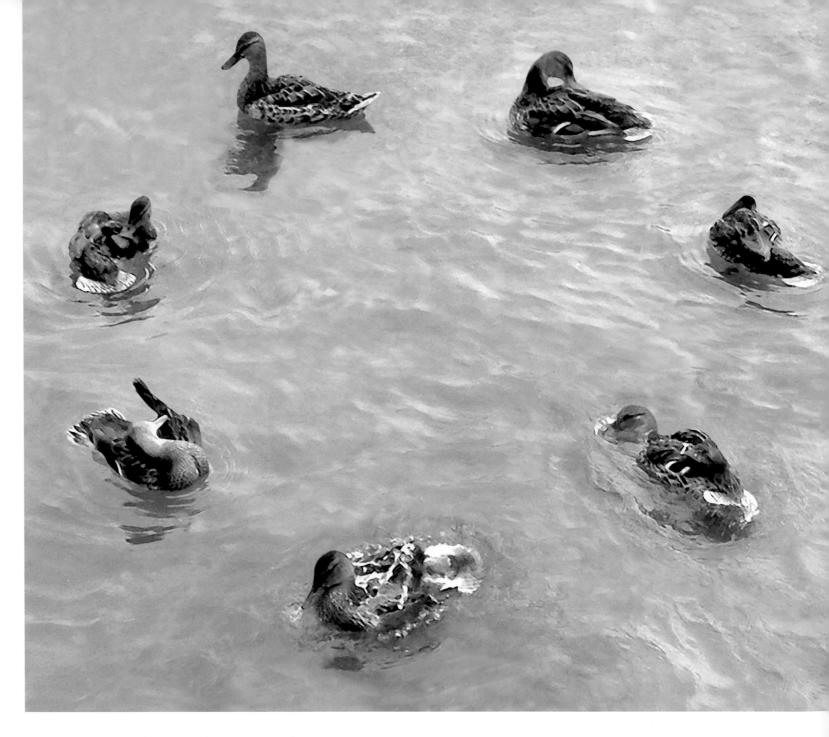

swimming in style,

and ...

D is for Dock, a place to sit for a while.

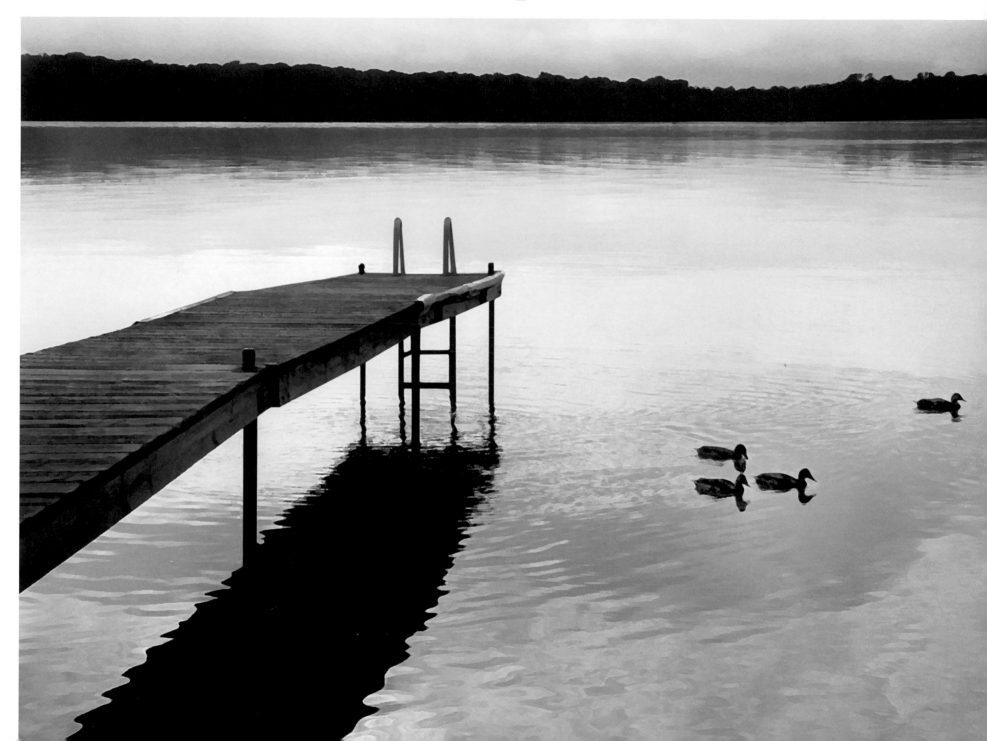

E e is for Exploring, and portaging too,

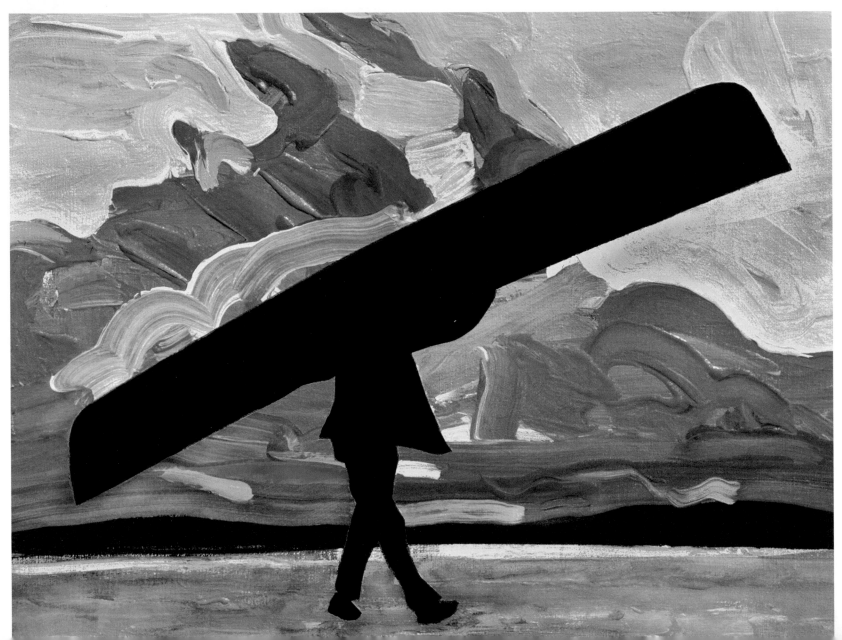

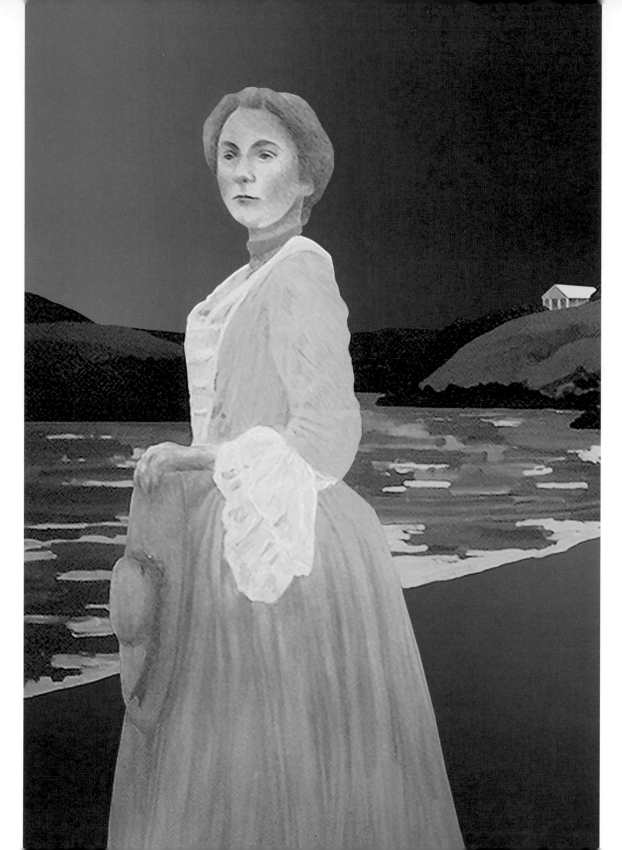

and for Elizabeth Simcoe, what a wonderful view.

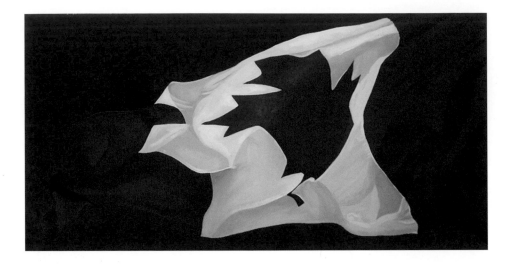

is for Flags

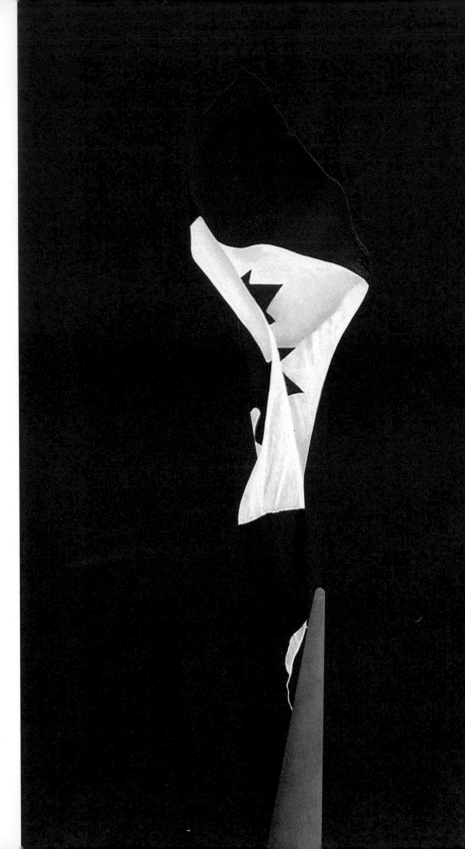

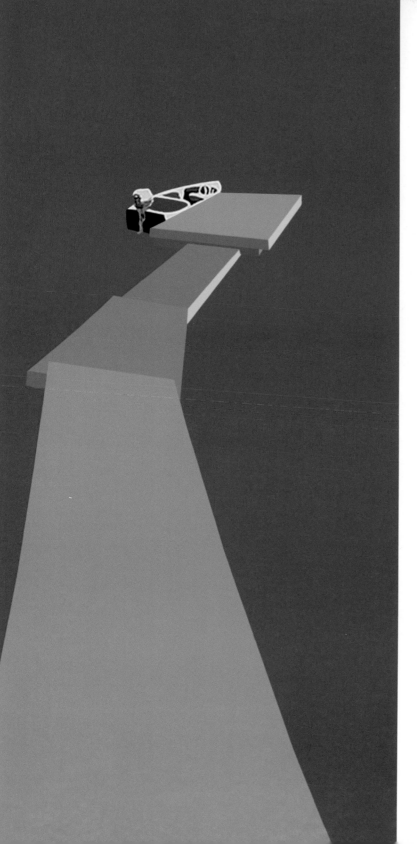

and Float

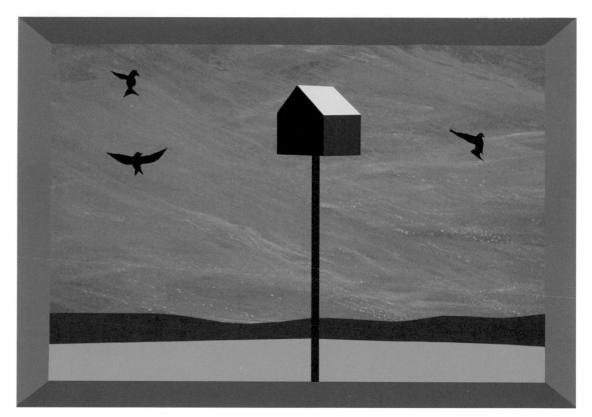

and Flight,

all looking magical, what a delight.

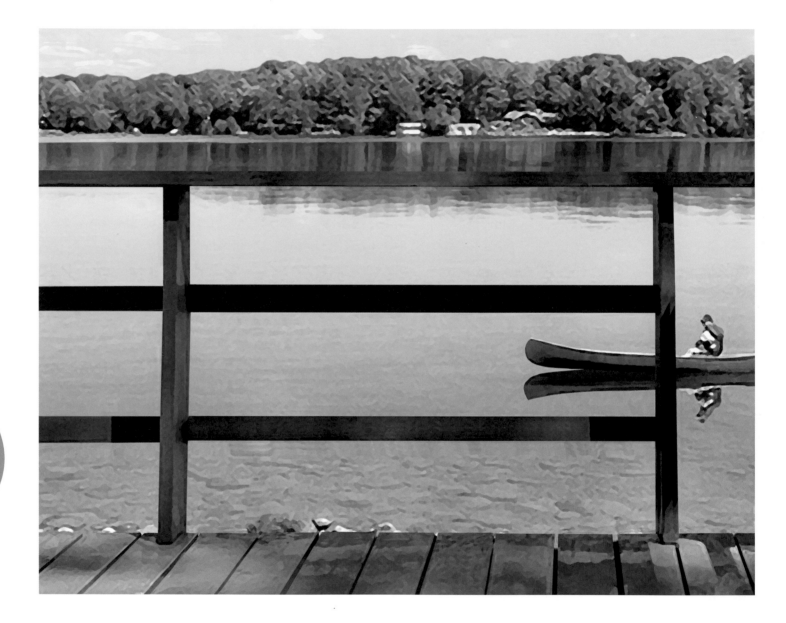

is for Glide

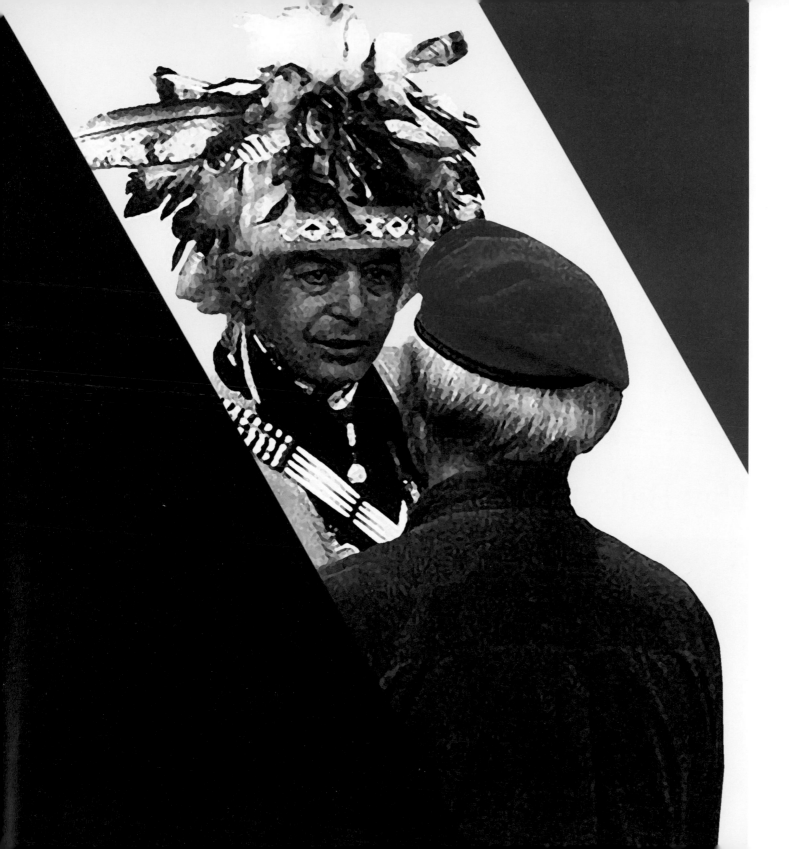

and Greeting old friends,

what a great adventure that never ends.

is for Highway,

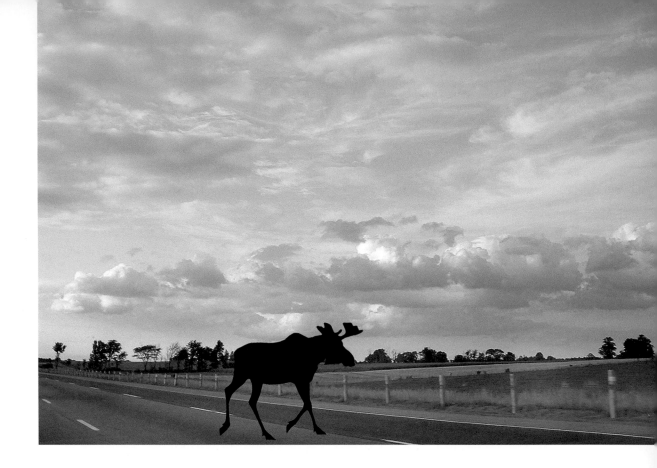

Hay Bales, and ...

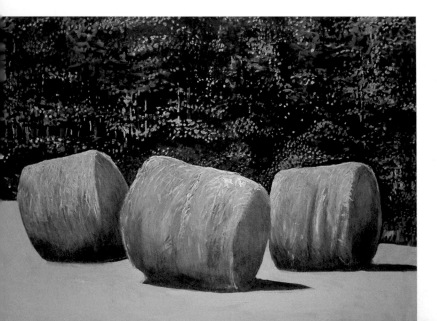

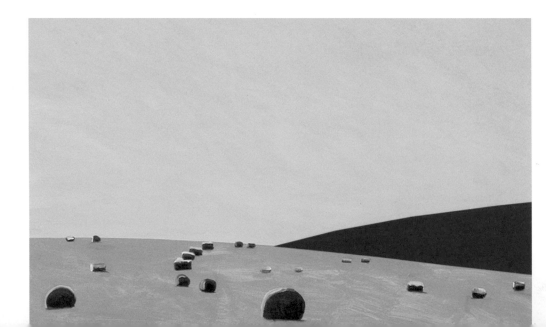

Hat.
A fine group of pictures, what do you think of that?

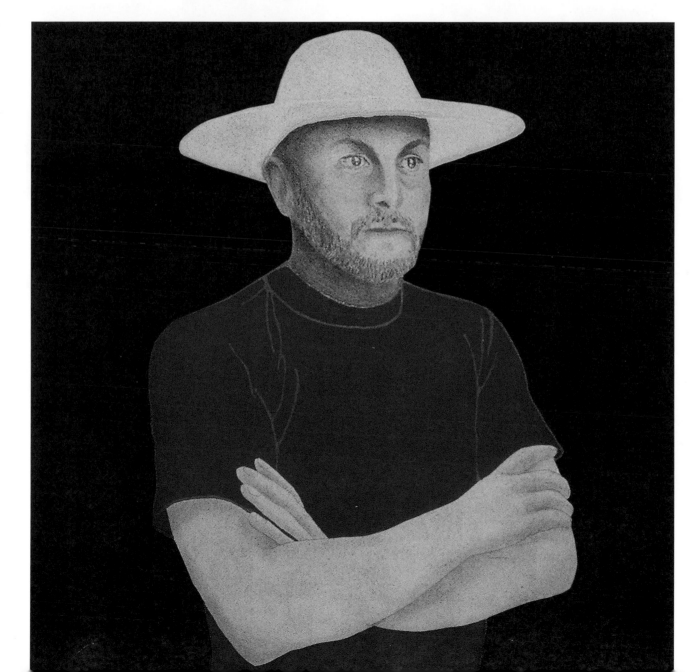

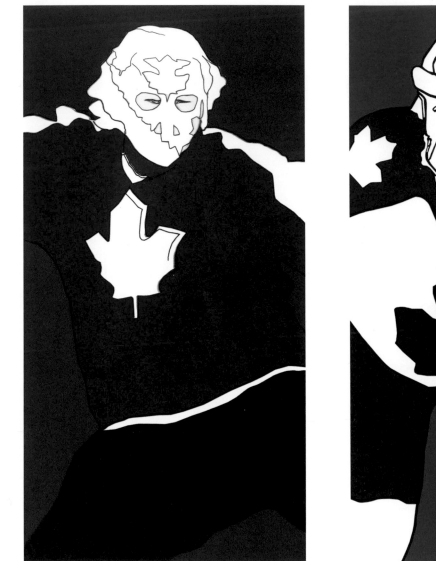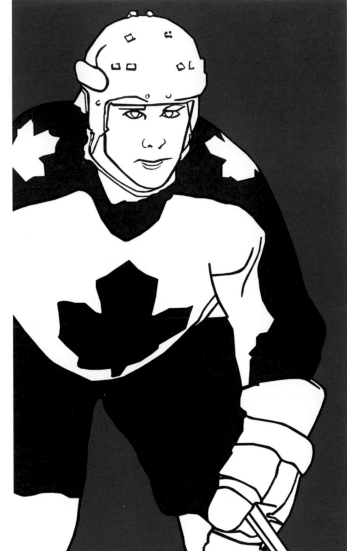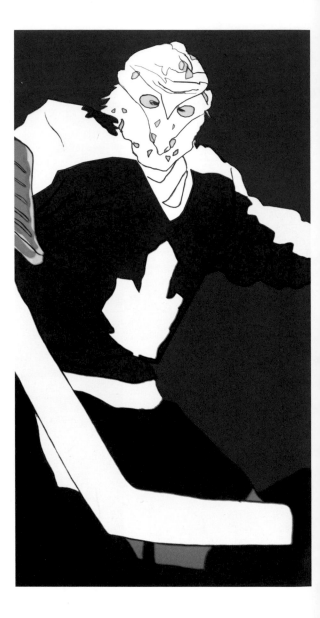

H is for Hockey, our Heroes, our boys,

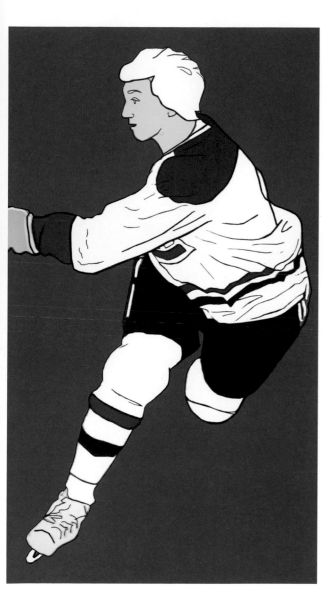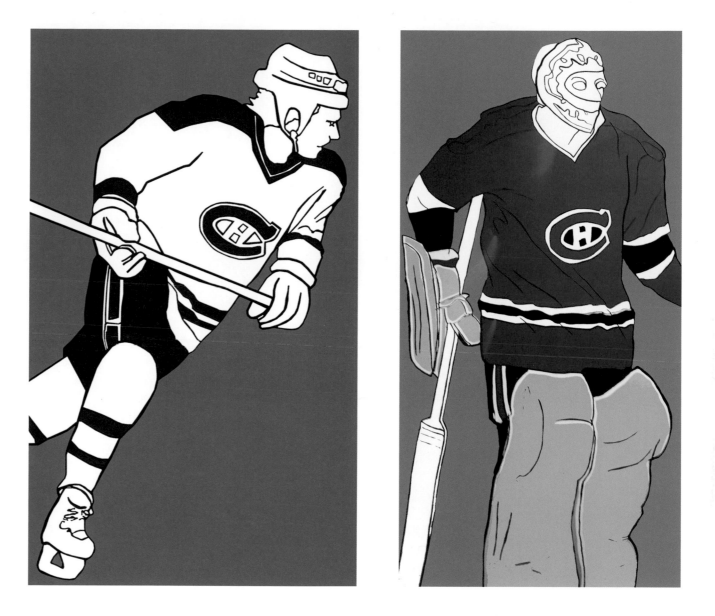

all of them players with our favourite toys.

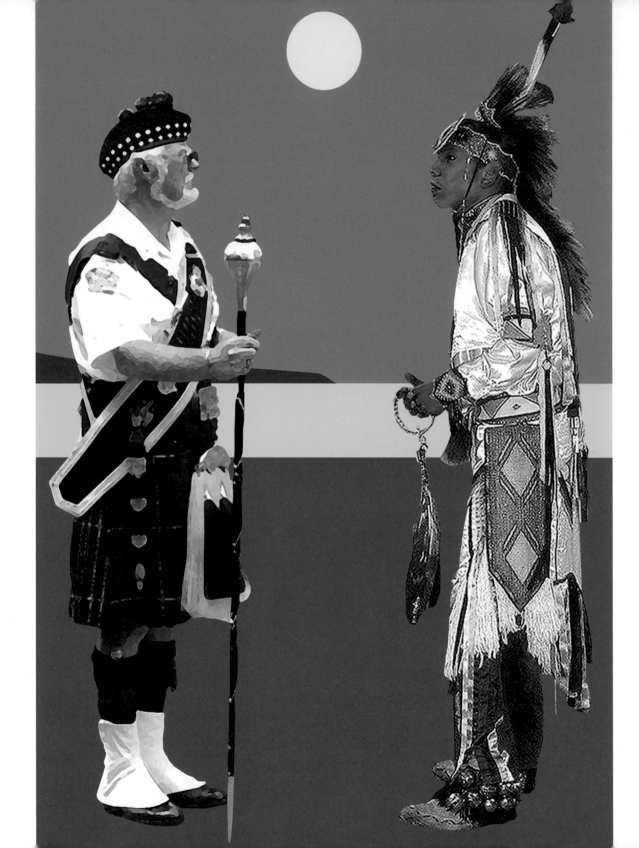

is for

Identity
and Igloo
and such.
Canada is so cool,
I love it so much.

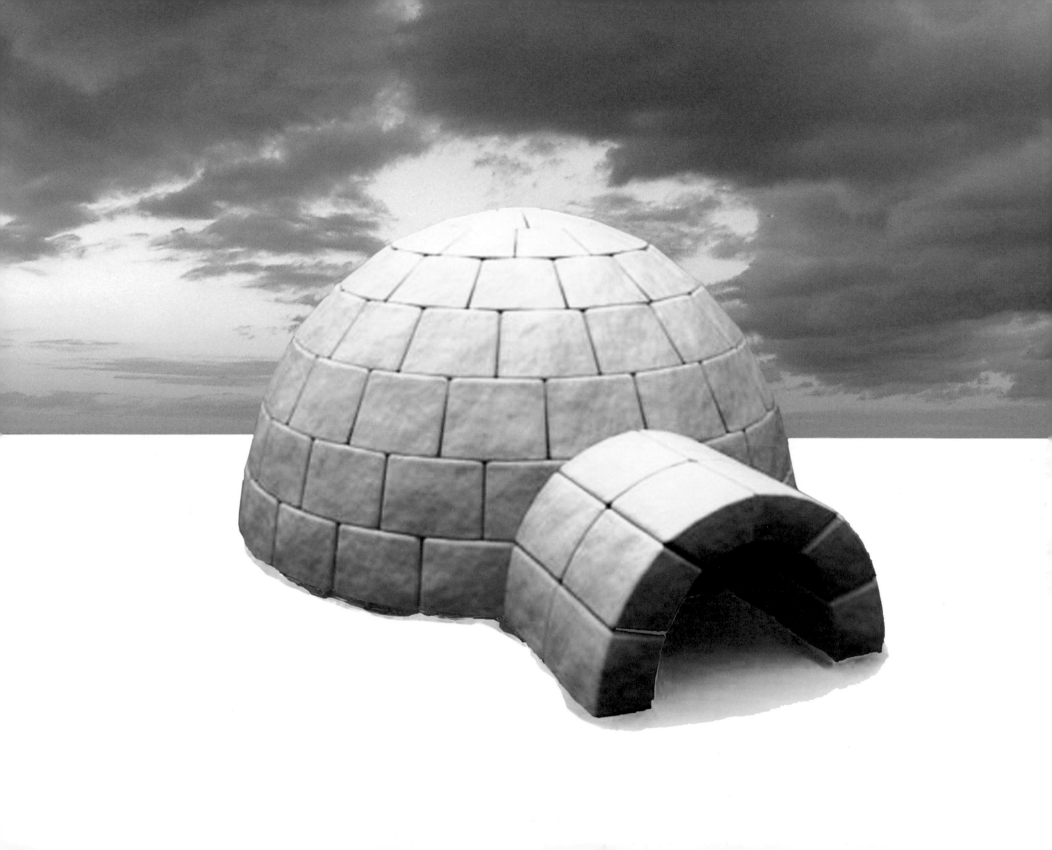

J

j

is
for
Joyride,
oh what
a hoot,

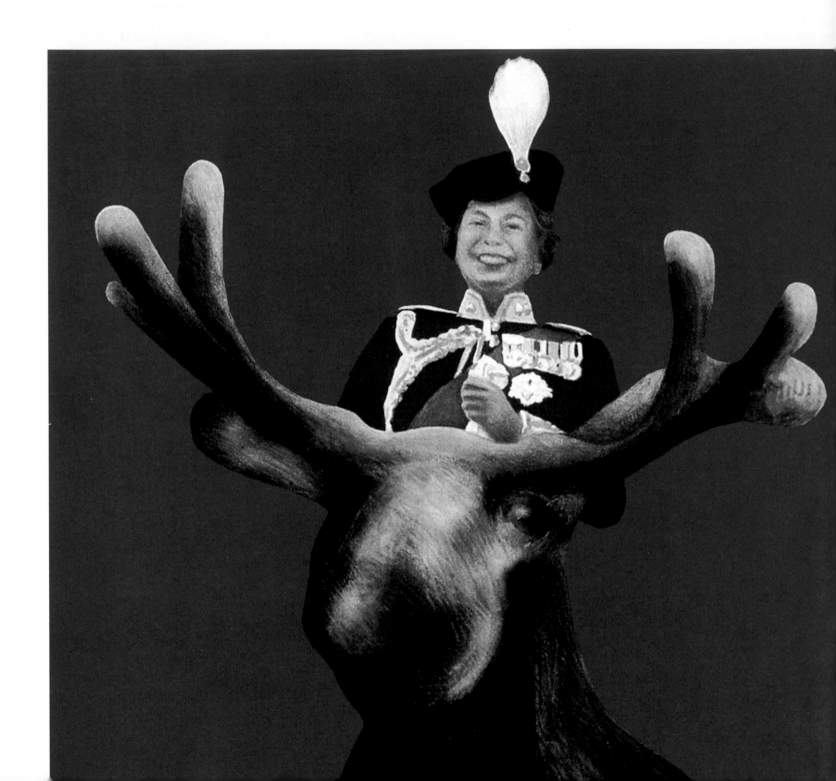

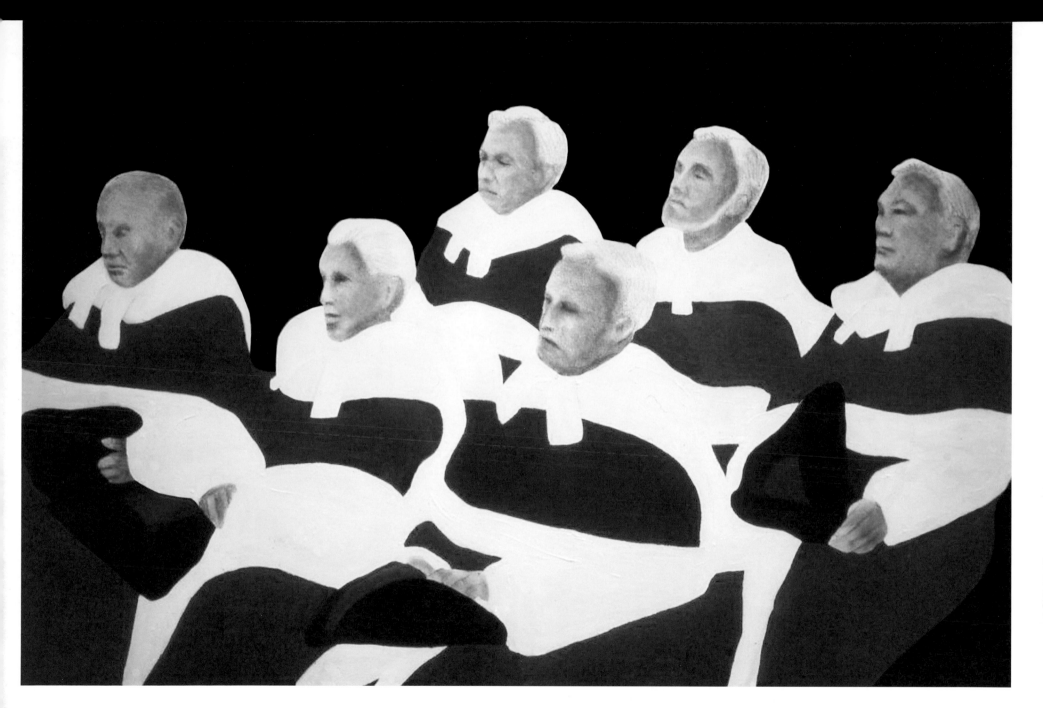

and J is for Judges,
we supremely salute.

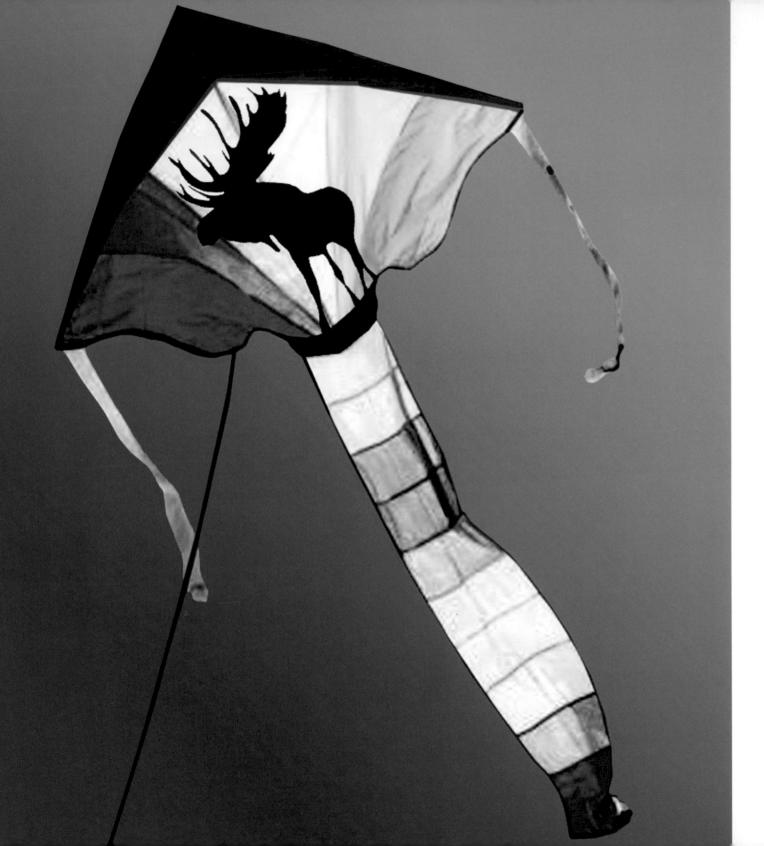

is for
Kite,
flying up
high,

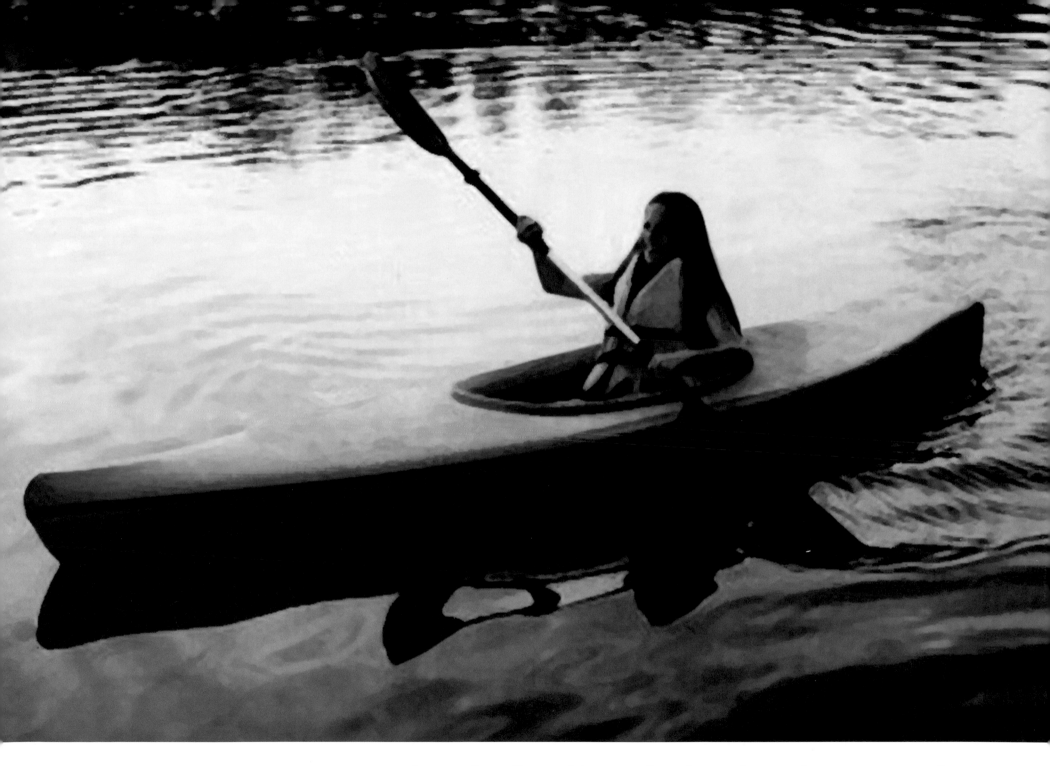

and K is for Kayak, in the river nearby.

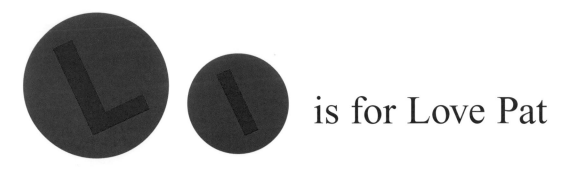 is for Love Pat

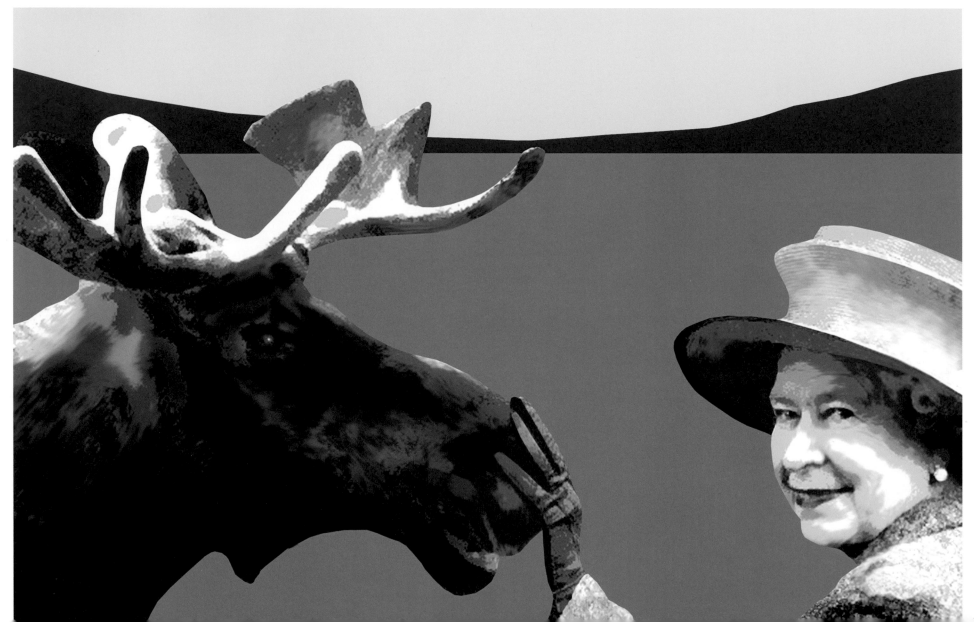

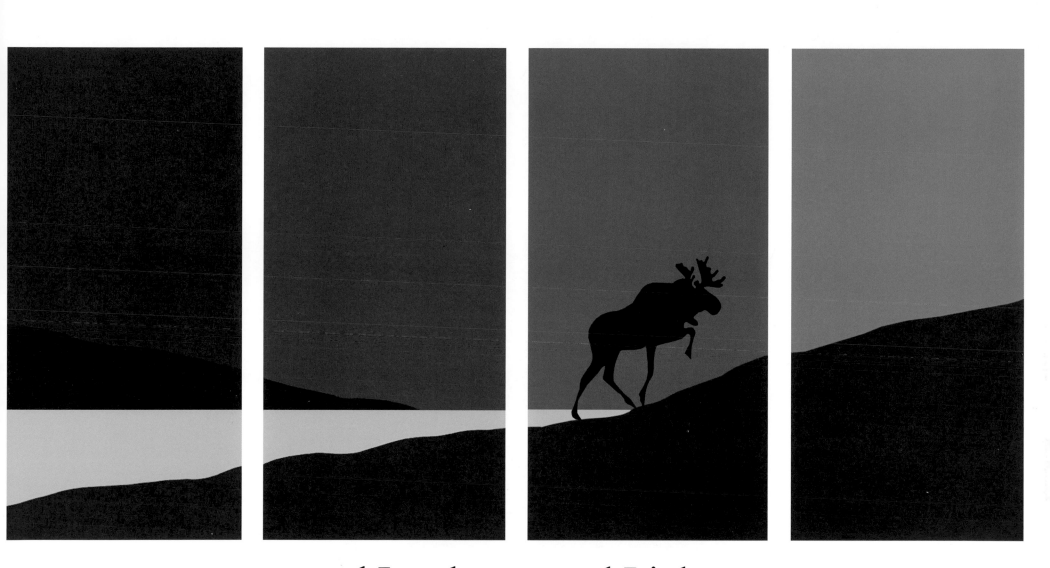

and Landscape and Light,
what a panorama, what a fine sight!

M m

is for
Moon

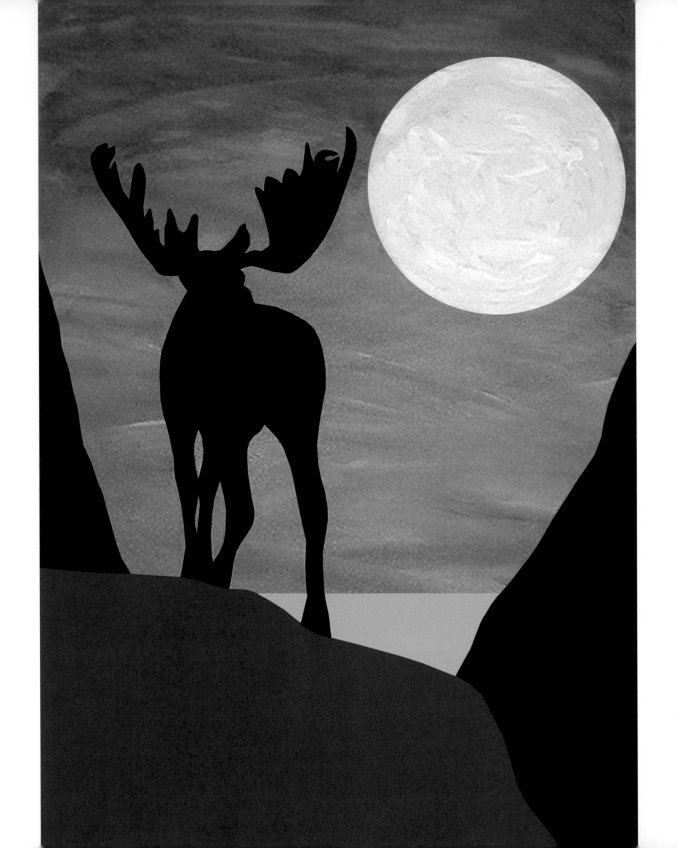

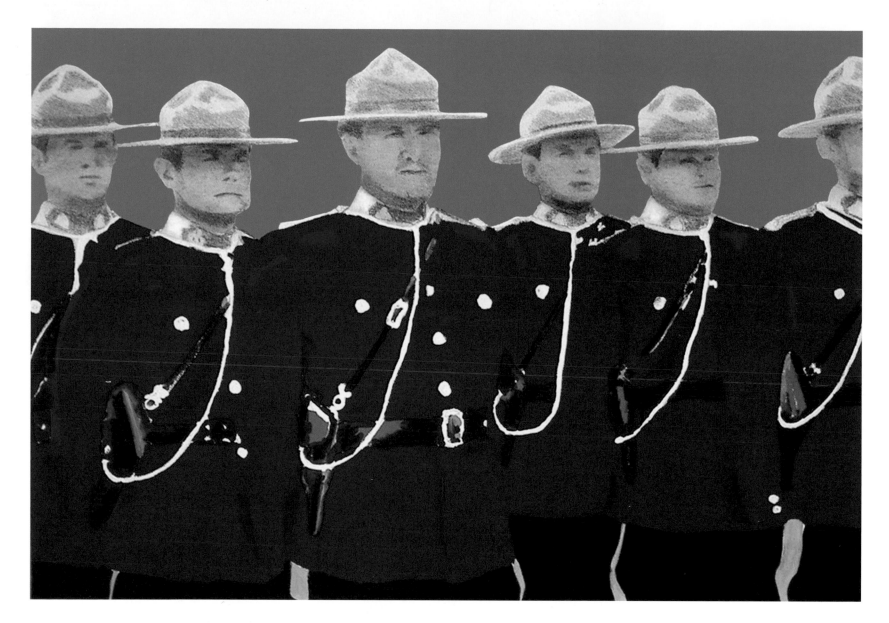

and Mounties

and Mother,

all of them
special, unlike
any other.

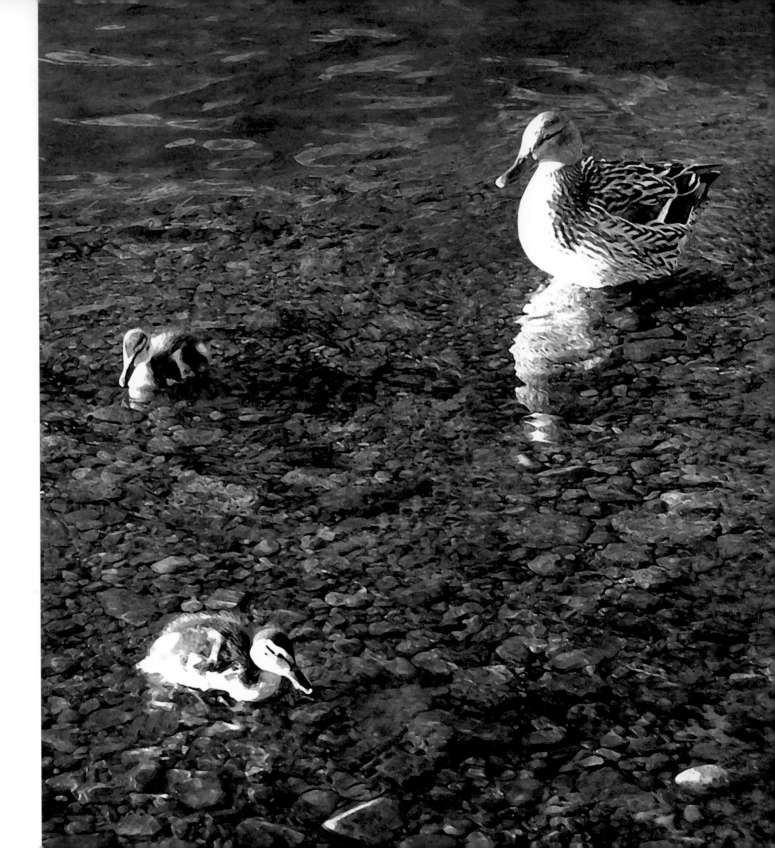

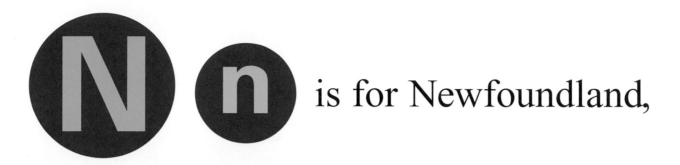 is for Newfoundland,

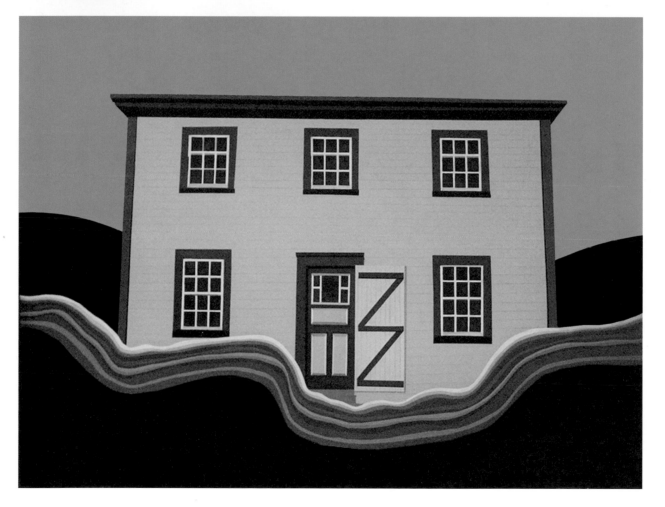

where Bumble Bee Bight is the name of a town.
And so are Nancy Oh and Blow-Me-Down.

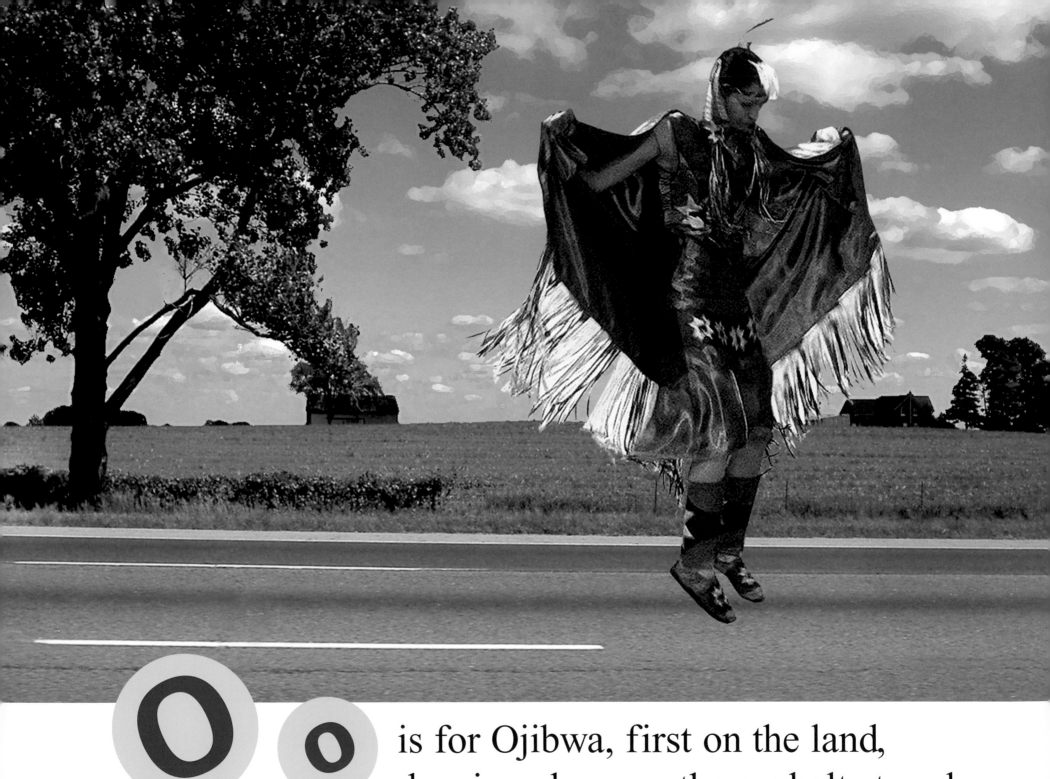

is for Ojibwa, first on the land,
dancing alone on the asphalt strand.

P p

is
for
Picnic.

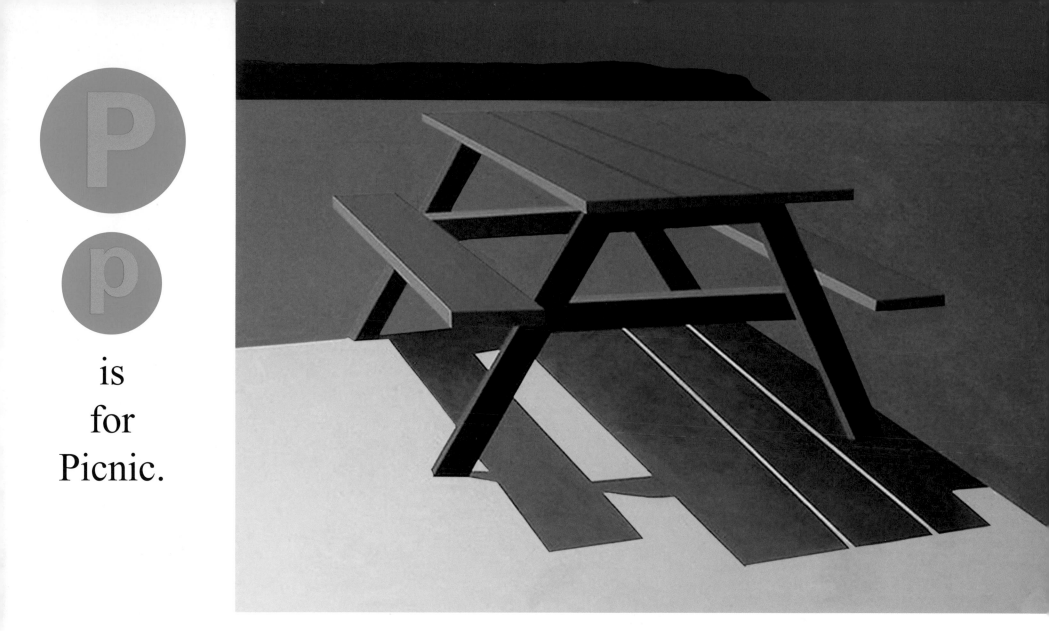

It's fun in the sun,
but when it rains,
your bun is undone!

P is for
Portrait,
a picture
with grace.

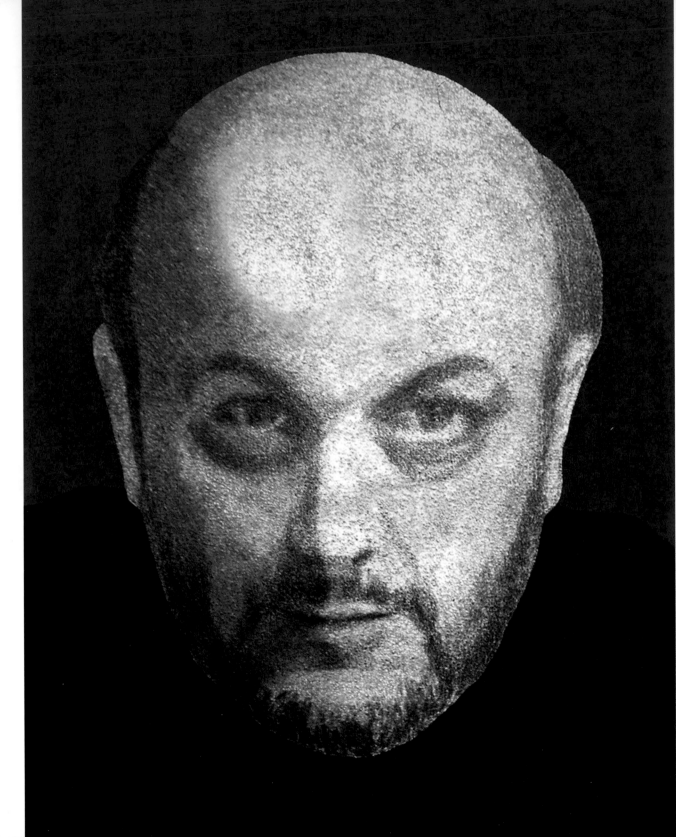

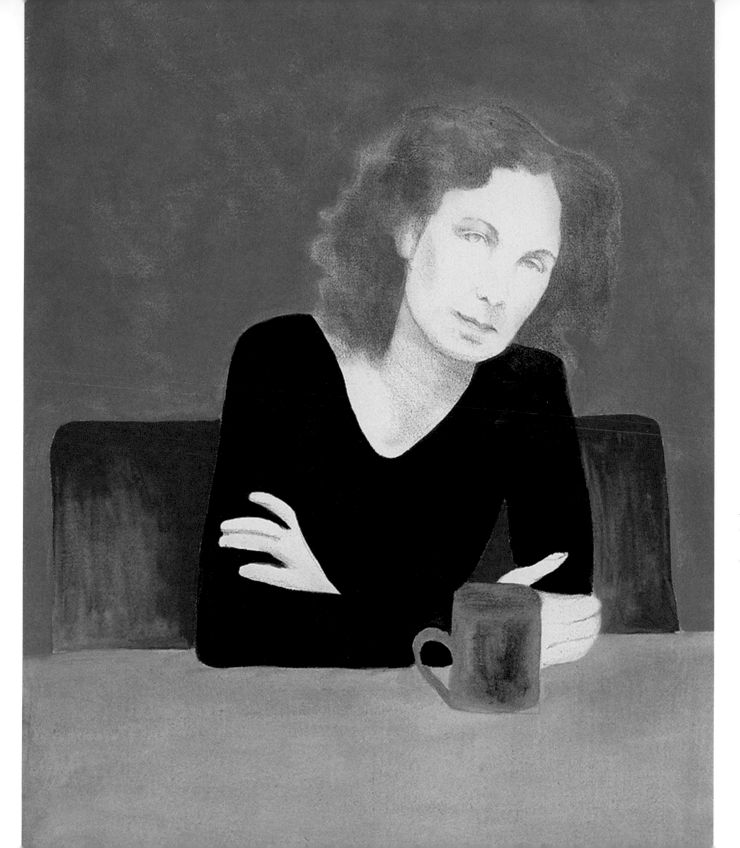

P is for
Poet, who
makes the
words race.

is for Queen,
trooping the colour.

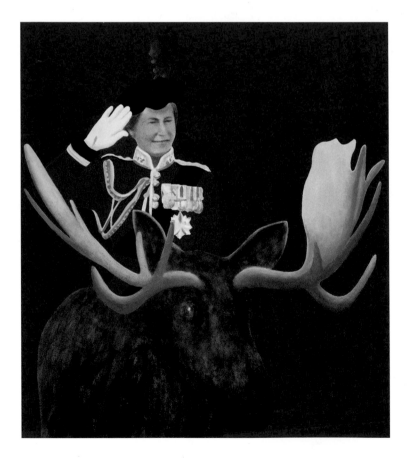

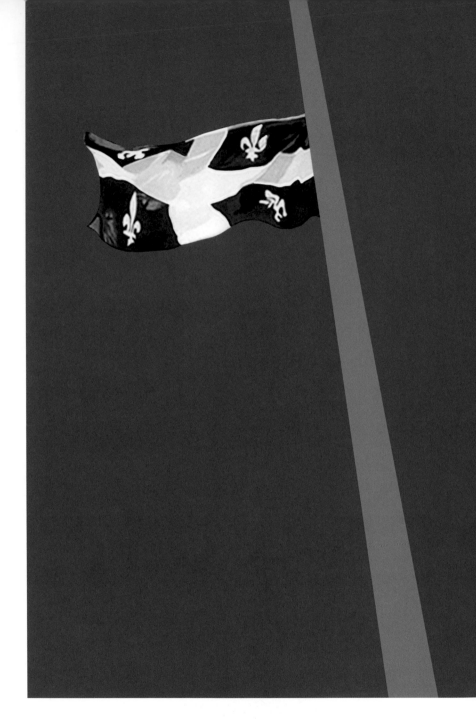

Q is for Québec,
savour the flavour!

 is for Red Barn Reflected,

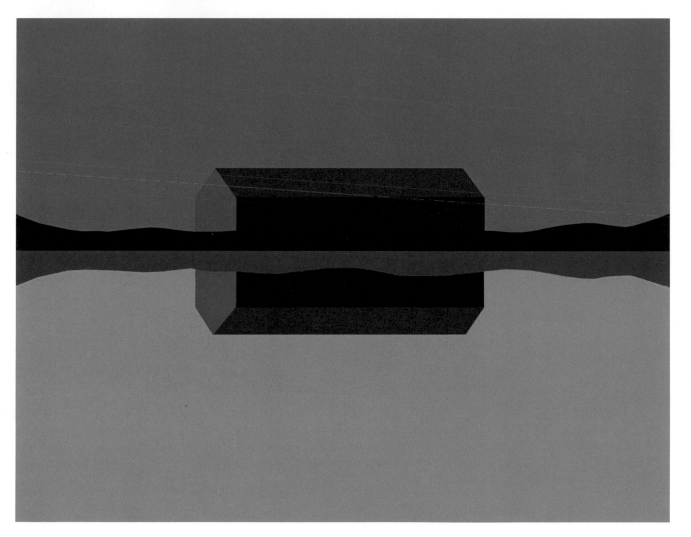

what beautiful colours the artist collected.

S **s**

is for

Simcoe,

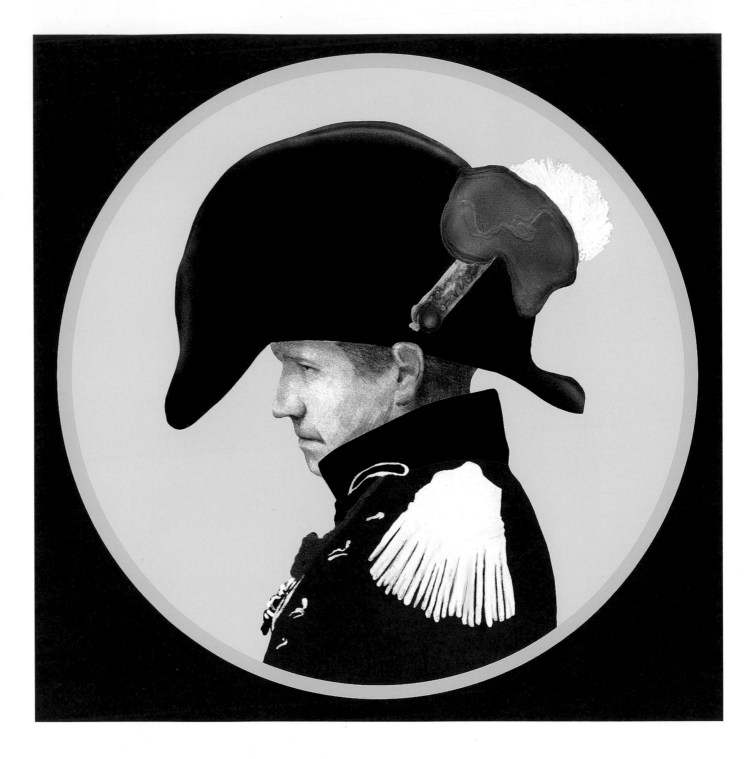

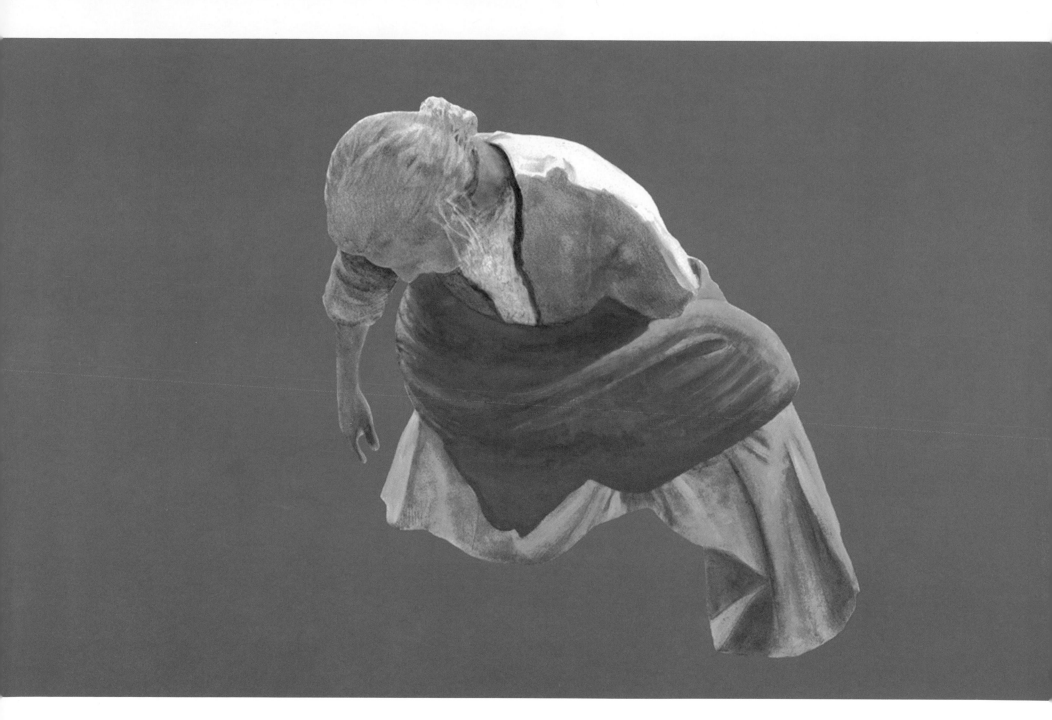

Susanna,

and
Spotlight.

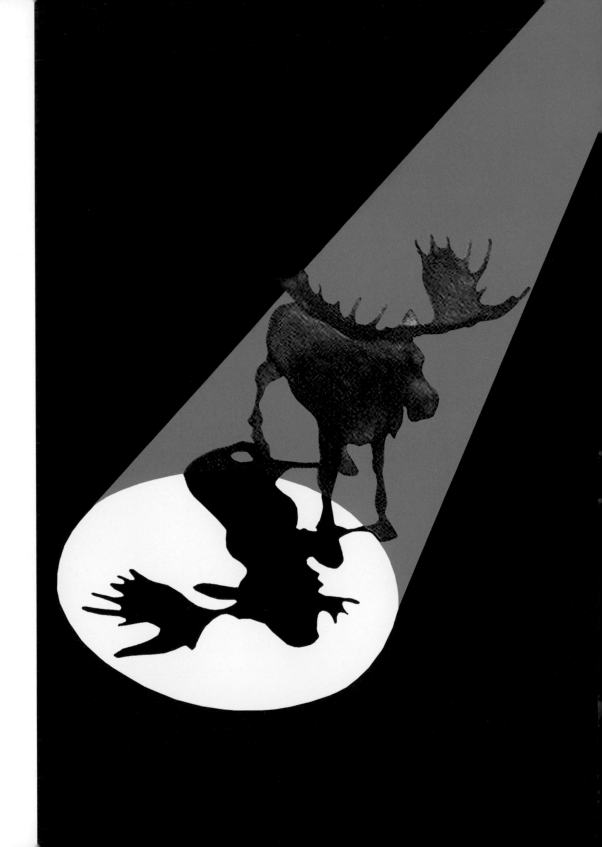

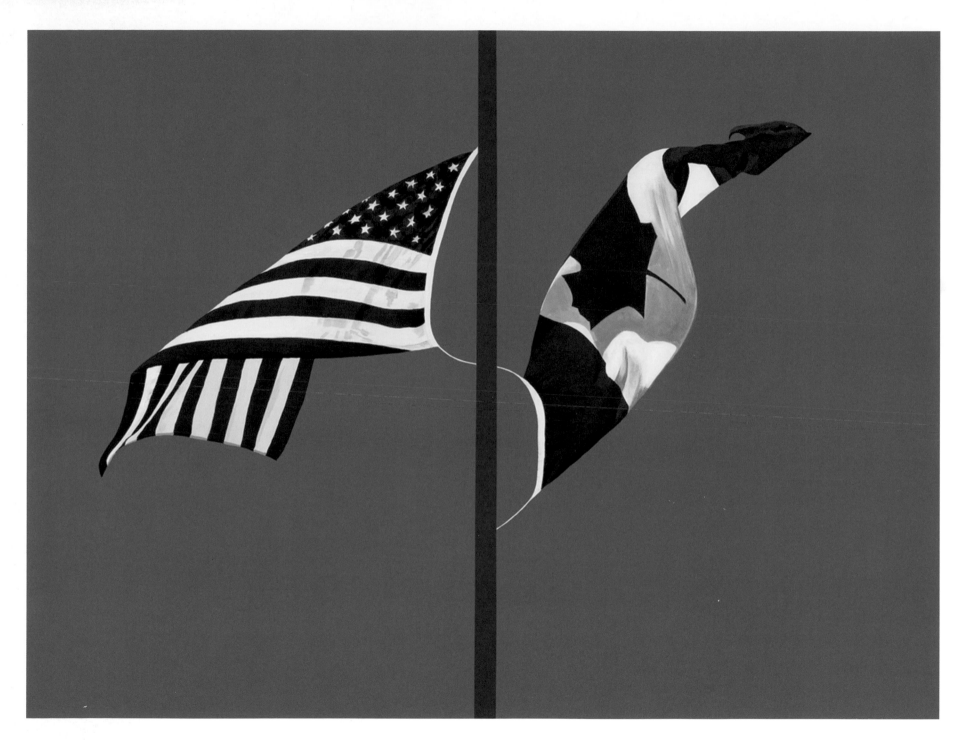

And S is for Side by Side, good neighbours all right!

T t

is for
red Tie,

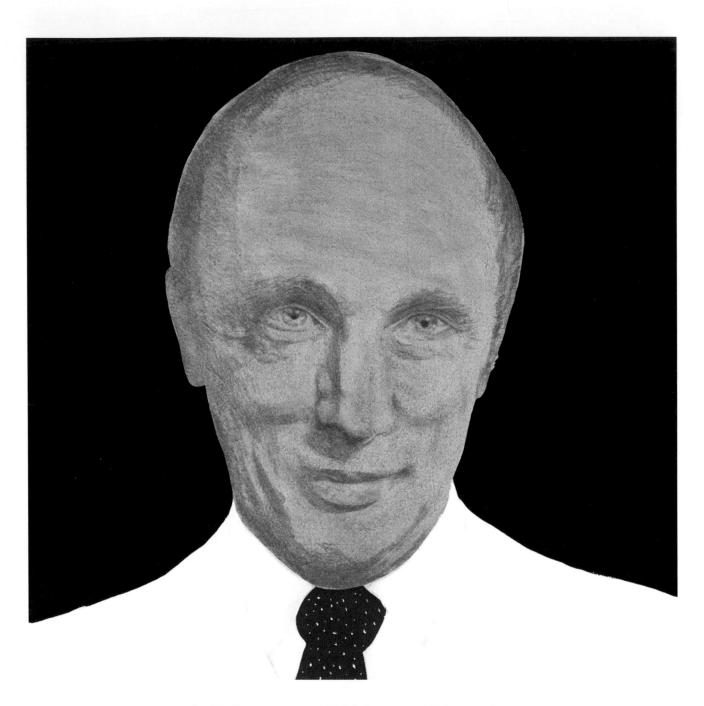

and Pierre Elliott Trudeau.

T is for Tightrope,
walk softly to and fro.

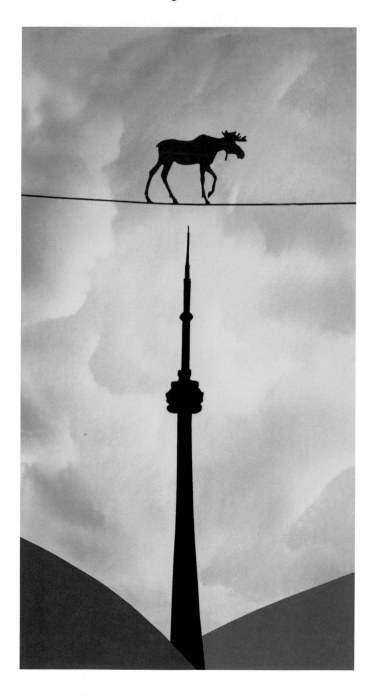

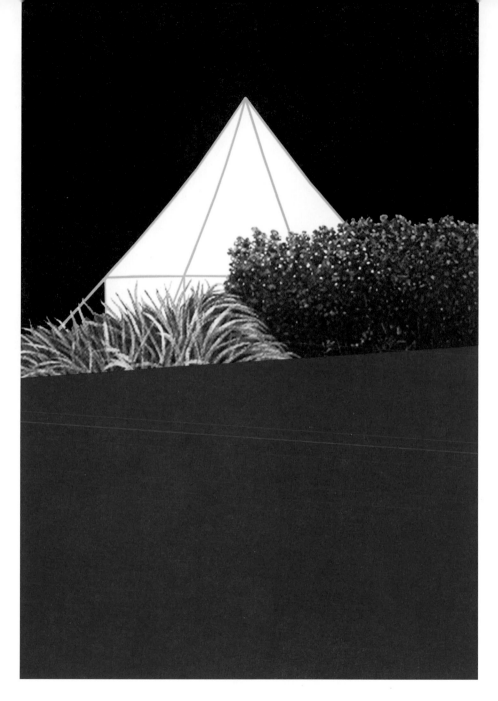

T is for Tent
and ...

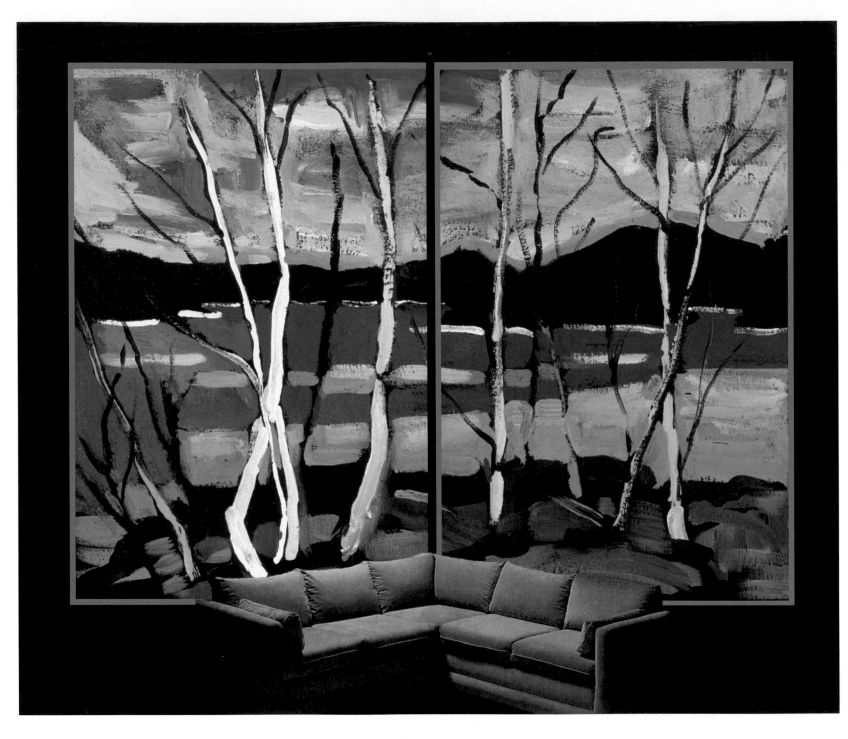

T is for Trees.

 is for Upside Down,

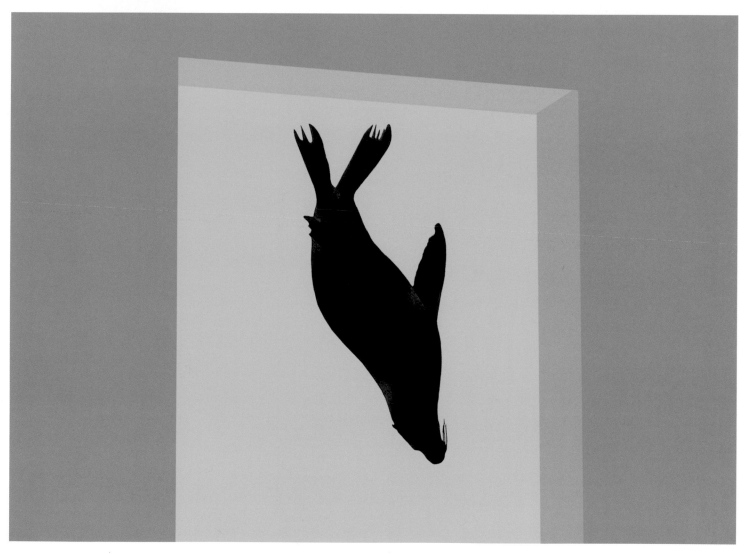

look what the seal sees!

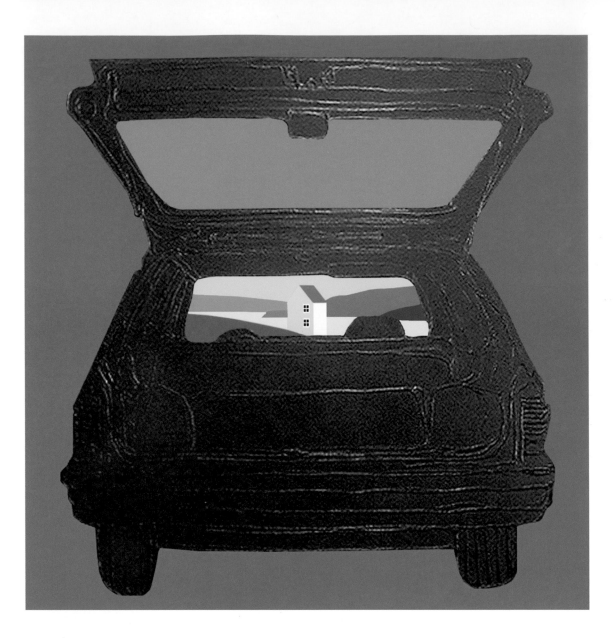

is for Vacation,
the best way to go.

 is for Winter, look at that snow!

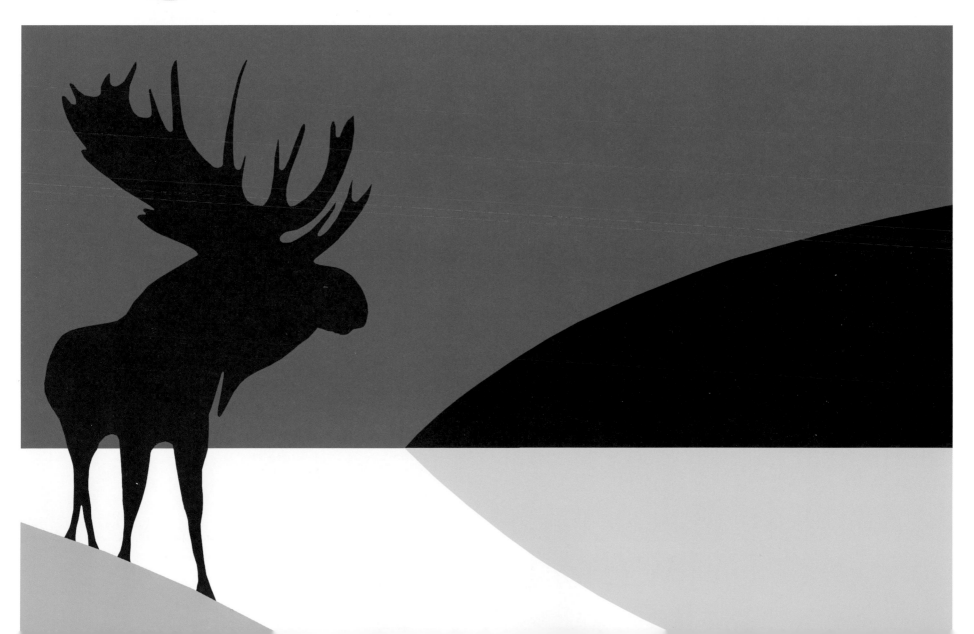

W is for Lake Winnipeg,

and Watching the ducks.

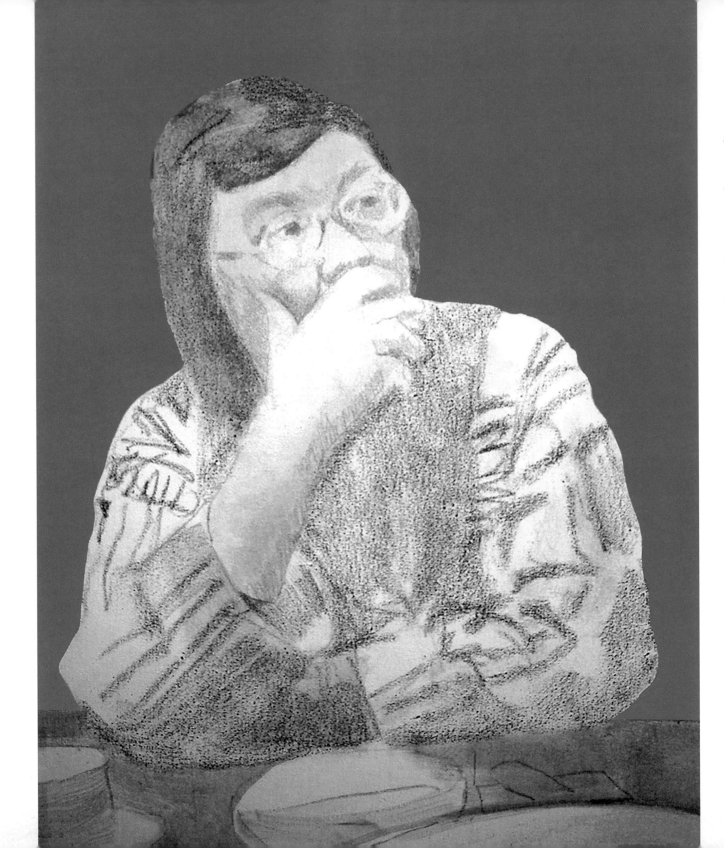

W is for
Writer,
storyteller
deluxe.

 is for X-ray, to find and to show.

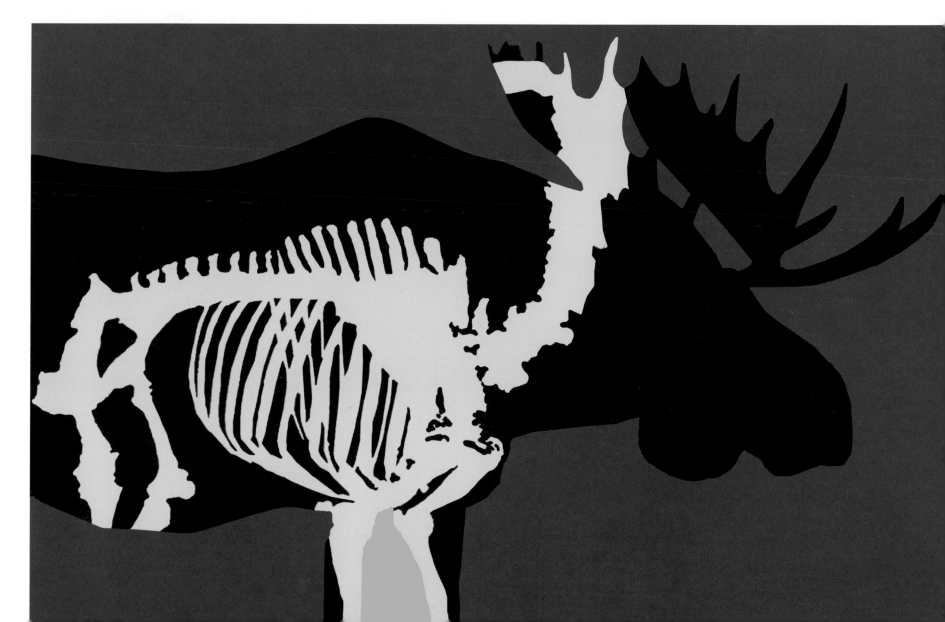

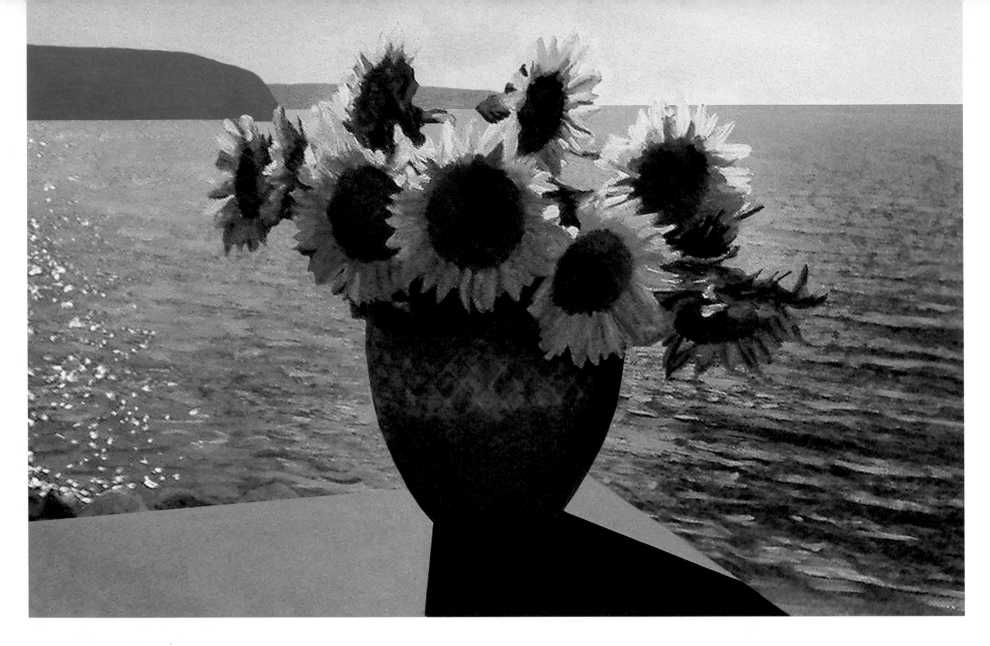

 is for Yellow, what a marvellous glow.

is for Zenith,
the highest
and best.

A good
place to end,
and a good
time to rest.

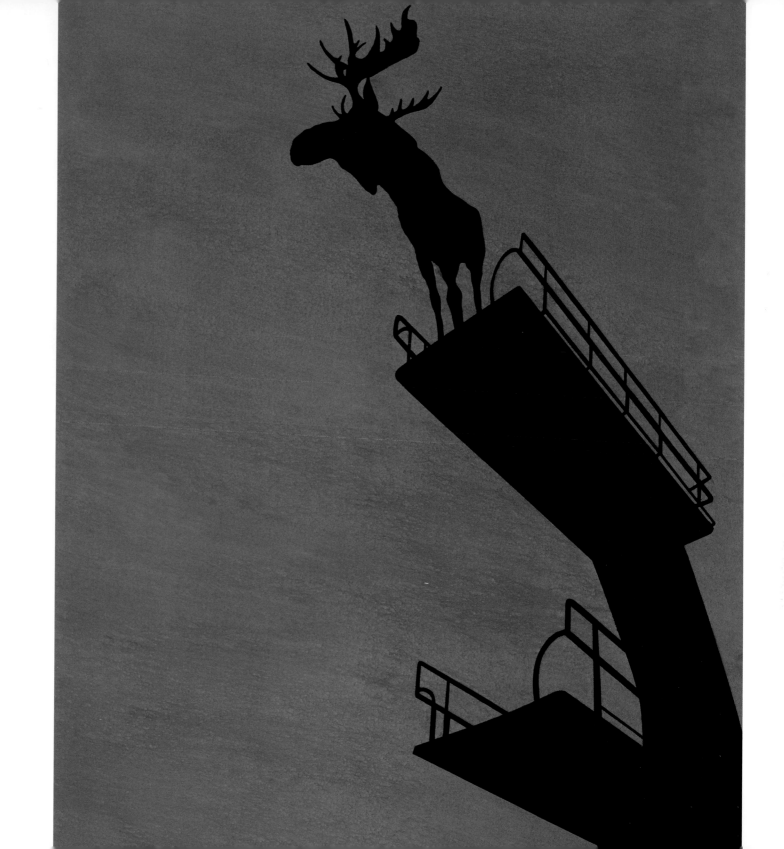

In His Own Words

I started drawing at age three and when I began to read soon after, I discovered that words could spark images in my head. Pictures and words looked good together! Then I perceived that words had subtle meanings, and when combined in different ways, they created sentences — ordered thoughts about the world I was beginning to know.

I grew up in Toronto in the 1940s and 1950s. It was a time of discovering anew what it was to be Canadian and it was particularly special for me. When the Canadian National Exhibition re-opened in the summer of 1947, after the Second World War, Canada's National Film Board made a film about "the Ex" featuring a mom and dad exploring the wonders of the fair with their curious son,

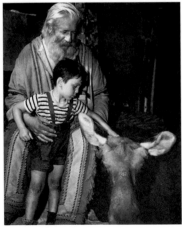

Charles pets a moose at the Canadian National Exhibition, Toronto 1947.

"Johnny." I was that four-year-old little boy. With a camera crew following me around for two weeks, I explored the fair, shook hands with Prime Minister Mackenzie King, and got kissed by Canada's Olympic ice skating champion Barbara Ann Scott.

That unexpectedly glamorous experience of my youth may have started my love affair with the images of this country, but there came many other seminal moments. I watched with pride the raising of our new maple leaf flag on February 15, 1965. I joined in the exuberance of Centennial Year in 1967, and took a job at Expo 67 in Montréal. I have always been fascinated by what defines Canada: our history, writers, wildlife, symbols, and diversity.

As a teenager, I was a summer camp counsellor in arts and crafts. One of my colleagues was wildlife specialist Margaret Atwood, then known as "Peggy Nature." We grew to share an interest in each other's creative life and I illustrated many of her poems for my graduate student thesis. Years later, when she sent me her brilliant and evocative set of poems *The Journals of Susanna Moodie*, I knew it would become a fountainhead for my imagination, and a catalyst for me to explore the ultimate Canadian experience of discovering and adapting to a new land.

When I was a fine arts student in university, it was often suggested to me by patronizing professors that the Canada of my imagination was not as important as the iconography from other places. If it came from elsewhere, it was consequential. If it came from here, not.

So I began to draw, paint, and make prints in which I wanted to make Canada look cool, elegant, interesting, even "glamorous," and put it on a level playing field with all those other countries I was told were more worthy of notice. While I was painting my Canada, Margaret Atwood, Dennis Lee, and Margaret Laurence were creating their Canada in their poetry and novels.

My experience was similar to that of many other visual artists, composers, and writers. Each of us has created a Canada that is unique, based on our accumulated life experiences, where we happen to live, who our friends are.

I hope you'll share this book with your children, grandchildren, and all who matter to you. This is a glimpse of how I see our Canada. My country. Your country.

How lucky can we get?

Charles Pachter

Best Butter Tart Recipe

Pastry Ingredients

5¼ cups all-purpose flour

3 tablespoons brown sugar

2 teaspoons salt

1 lb. of vegetable shortening

1 egg

2 teaspoons white vinegar

up to one cup ice-cold water

Filling Ingredients

1 cup currants or raisins

½ cup unsalted butter

1 cup brown sugar

1 cup corn syrup

½ teaspoon salt

1 teaspoon pure vanilla

2 eggs, beaten lightly

Pastry

Mix together first three ingredients, then blend in shortening until mixture forms into small pea-like clumps.

Separately, blend together egg, vinegar, and no more than three-quarters of a cup of the ice water. Add this to the flour and shortening mixture, mixing the ingredients loosely with fingers. Add extra water — up to an additional quarter-cup — as necessary. Pastry dough should just hold together (remember: the less you handle it, the better it will be).

Form two discs out of the dough. Wrap well in waxed paper and then plastic wrap, and place in refrigerator for at least three hours (the dough will keep in the refrigerator for up to twenty-four hours).

Take pastry dough out of refrigerator and roll out on well-floured surface with well-floured rolling pin. Cut out circles to fit in tart tins.

Preheat oven to 425°F.

Filling

In a heavy saucepan, combine ingredients except the vanilla and eggs. Set over low heat until butter is melted and mixture is warm. Remove from heat. Add vanilla, wait a few minutes for the mixture to cool, and then add eggs. Mix quickly.

Fill empty tart shells two-thirds full and bake for ten minutes. Reduce heat to 350°F and continue baking for five minutes or until pastry is golden brown. Do not allow filling to bubble over. Remove tarts from oven and let cool completely before removing from tins.

Makes 18 tarts.

Games to Play

Counting

1. How many moose are in the book?

2. How many ducks are in the book?

3. How many barns are in the book?

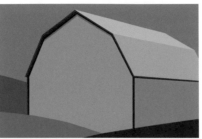

4. How many flags are in the book?

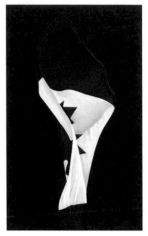

5. How many canoes are in the book?

1. There are 19 moose in the book. You can find them on the following pages: 1 on the copyright page; 2 on C is for Crossing; 1 on H is for Highway; 1 on J is for Joyride; 1 on K is for Kite; 1 on L is for Love Pat; 1 on L is for Landscape; 1 on M is for Moon; 1 on Q is for Queen; 1 on S is for Spotlight (don't count the shadow); 1 on T is for Tightrope; 1 on W is for Winter; 1 on X is for X-ray; 1 on Z is for Zenith; 2 on In His Own Words; 1 in the notes for Q is for Queen; and one on this page!

2. There are 25 ducks in the book. You can find them on the following pages: 7 on D is for Ducks; 4 on D is for Dock; 3 on M is for Mother; 4 on W is for Lake Winnipeg; 6 on W is for Watching the ducks; and one on this page!

3. There are 6 barns in the book. You can find them on the following pages: 1 on A is for Alberta; 2 on B is for Barns; 1 on O is for Ojibwa; 1 on R is for Red Barn Reflected; and one on this page!

4. There are 8 flags in the book. You can find them on the following pages: 2 on F is for Flags; 1 on Q is for Québec; 2 on S is for Side by Side; 1 in the notes for F is for Flags; 1 in the notes for The Loyalists; and one on this page!

5. There are 5 canoes in the book. You can find them on the following pages: 1 on C is for Canoe; 1 on E is for Exploring; 1 on G is for Glide; 1 on K is for Kayak (a kayak is a type of canoe); and, yes, one on this page, too!

About the Images

B is for Butter Tarts. A different recipe.

Filling Ingredients

1 cup white sugar
¼ cup unsalted butter
1 egg
1 teaspoon pure vanilla
Pinch of salt, if desired
1 cup currants

Mix together well and spoon into uncooked pastry shells. Bake in hot oven, preheated to 400° F, eleven minutes for small pastry shells, fifteen minutes for large. Cool completely before eating. Recipe is courtesy of Joyce Monro.

C is for Castle Frank. Castle Frank was the name given to the summer residence that John and Elizabeth Simcoe built a mile north of the tiny wilderness capital of York, Upper Canada (now Toronto). The house, made of rough-hewn wooden logs, was built high up on a steep hill overlooking the Don River, on land that is now in the neighbourhood of Rosedale in downtown Toronto. Construction began in the spring of 1794 and the Simcoes named the house after their five-year-old son, Francis, who lived with them in the wilderness and who was to inherit the residence. The Simcoe

family returned to England in 1796. Young soldier Francis Simcoe was killed during the British siege of Badajoz, Spain, in 1812. Castle Frank remained uninhabited, and was accidentally burned down in 1829.

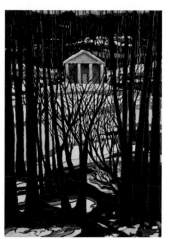

E is for Elizabeth Simcoe. Elizabeth Posthuma Gwillim as born September 22, 1762. Her middle name "Posthuma" comes from Latin, meaning "after death," as she was born after her father died and was baptized the day her mother died. A wealthy orphan, she was raised by her aunt and her aunt's husband, Admiral Samuel Graves. She met and

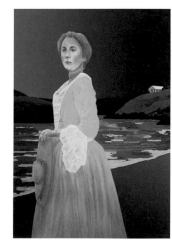

married the admiral's godson, John Graves Simcoe, who had fought for Britain in the American Revolutionary war. The Simcoes moved from England to the newly created British province of Upper Canada in 1791, when

John Graves Simcoe became the first Lieutenant Governor. They lived in the village of Newark (now Niagara-on- the-Lake), York (now Toronto), and Québec. Mrs. Simcoe painted watercolours and kept a diary that provides a vivid description of her five years in "the Canadas," as the Upper and Lower provinces were then called (now Ontario and Québec). She savoured the experience of living in the Canadian wilderness and considered the primitive living conditions encountered as challenging adventures. The Simcoes had eleven children. Mrs. Simcoe died in England on January 17, 1850.

Note: in the background of the image, the structure is Castle Frank, which overlooked the Don River — that's the view.

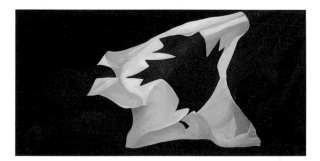

F is for Flags. The official ceremony inaugurating the new Canadian maple leaf flag was held on Parliament Hill in Ottawa on February 15, 1965, with Governor General Georges Vanier, Prime Minister Lester B. Pearson, the members of the Cabinet, and thousands of Canadians in attendance. The following words were spoken on that

momentous day by the Honourable Maurice Bourget, Speaker of the Senate:

"The flag is the symbol of the nation's unity, for it, beyond any doubt, represents all the citizens of Canada without distinction of race, language, belief or opinion."

P is for Portrait. This is a self-portrait by the artist. Charles Pachter was born in Toronto on December 30, 1942. He is a painter, printmaker, sculptor, designer, historian, and lecturer. He studied French literature at the Sorbonne in Paris, painting and graphics at the Cranbrook Academy of Art in Michigan, and art history at the University of Toronto. His work has been shown at the Royal Ontario Museum, the Art Gallery of Ontario, and the McMichael Gallery, among others. His work is represented in public and private collections in Canada, the U.S., Europe, Japan, and India. The artwork on the H is for Hockey pages can be seen in the College Subway Station in Toronto, where the murals of the Montréal Canadiens face the Toronto Maple Leafs across the subway tracks. He is a member of the Order of Canada and lives in downtown Toronto, near the Art Gallery of Ontario.

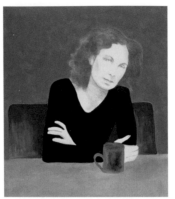

P is for Poet. Margaret Atwood was born in Ottawa on November 18, 1939. She is a renowned poet, novelist, and essayist. She was educated at Victoria College, University of Toronto, Radcliffe College, and Harvard University. Among her eighteen poetry books are: *Double Persephone*, *The Journals of Susanna Moodie*, *Power Politics*, and *The Door*. Her twelve novels include *The Edible Woman*, *Cat's Eye*, and *Oryx and Crake*. She won the Governor General's Literary Award for her book of poems, *The Circle Game*, and for her novel, *The Handmaid's Tale*. Her novel *Alias Grace* won the Giller Prize and her novel *The Blind Assassin* won the Booker Prize. She has taught at several universities in Canada and the U.S., and has been a president of The Writers' Union of Canada and International PEN Canada Centre (English Speaking). She is a companion of the Order of Canada. She lives in Toronto, where she is active in the Green Party.

Q is for Queen. The British custom of Trooping the Colour dates back to the 17th century when the colours of a regiment were displayed to rally troops for battle. For the first time, in 1805, Trooping the Colour was performed to mark the monarch's

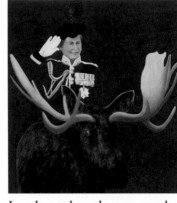

birthday — George III. Since the 1950s this display of pageantry takes place in June each year to celebrate the official birthday of the Queen. In London, when she was much younger, the Queen attended the event seated sidesaddle on her horse. In his painting, Charles depicts Her Majesty seated sidesaddle on a moose, symbolizing her role as Canada's head of state.

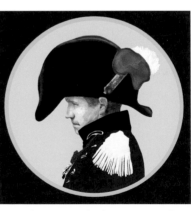

S is for Simcoe. John Graves Simcoe was born in Cotterstock, England, on February 25, 1752. He fought in the American Revolution, returned to England, and later returned to North America to become the first Lieutenant Governor of the newly created province of Upper Canada (now Ontario) from 1791 to 1796. Simcoe enthusiastically encouraged the settlement of Upper Canada by the Loyalists,

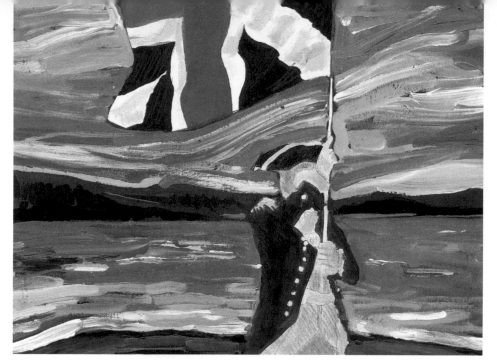

The Loyalists

mostly American-born colonials living in the Thirteen Colonies who had remained loyal to Britain and left the new United States as political refugees. He played a significant role in bringing English common law, trial by jury, and proper courts to Upper Canada, where he established the capital, York, now called Toronto. He abolished slavery in Upper Canada, a process begun in 1793 and in full force by 1810. Simcoe died on October 26, 1806, on his way to India, where he was to be the Governor-General.

The Loyalists. A direct result of the American Revolution was the political creation of British North America (later, English Canada) and the policy to populate the new colony with a critical mass of political refugees from the former Thirteen Colonies. Seven years after the Declaration of Independence, the 1783 Treaty of Separation officially declared Britain's former American colonies as the new United States of America. Britain then initiated a decade-long salvage-and-rescue operation to assist persecuted Anglo-American loyalists, many dispossessed of their properties and banished from their former homes, by relocating them to safer haven in Canadian territory, under temporary British military rule. The province of New Brunswick was created specifically for Loyalist refugees.

The Loyalist Decade (1783–93) witnessed the creation of Canada's four founding provinces, nearly seventy-five years before Confederation in 1867. In 1784, the Fourteenth Colony, Nova Scotia (formerly Acadia under the French regime), was divided in two to create the new provinces of Nova Scotia and New Brunswick, where Loyalists flocked to instantly designated settlements in the wilderness, suffering untold misery and deprivations. But they persisted, cutting down the forests and planting government-rationed seeds, living on meagre supplies in hastily constructed shelters. Their efforts paid off.

In 1791 Britain took the next major step, passing the Constitution Act, which divided the immense territory of British-administered Québec that extended west to the present state of Ohio into two jurisdictions, creating Lower Canada as a predominantly French-speaking province, and the former western half as Upper Canada, designated as a predominantly English-speaking province, a sort of Consolation Prize (*Cold Comfort*) for more loyalists. (The "upper" and "lower" designations were based on the flow of the St. Lawrence River: Ontario was upriver and Québec, downriver.)

S is for Susanna. Born Susanna Strickland near Bungay, Suffolk, England, on December 6, 1803, Susanna Moodie was a prolific writer of poetry, short stories, articles, and novels. She published her first children's book in 1822, in London, where she was involved in the anti-slavery movement. She married John Moodie and together

with their daughter immigrated to Canada in 1832. In 1852, she published her best-known work, *Roughing It in the Bush*, a personal narrative of her immigration to Canada and her experience living in the wilderness of Douro township, near what is now Peterborough. In 1853, she published *Life in the Clearings Versus the Bush*, which was based on her life in the town of Belleville, where she had moved with her husband who was the sheriff there. She remained in her cottage in Belleville after her husband's death, and lived to see Confederation in 1867. She died in Toronto on April 8, 1885.

T is for red Tie and Pierre Elliott Trudeau.
Born in Montréal on October 18, 1919, he was the fifteenth prime minister of Canada. He was educated at Jean-de-Brébeuf, a *collège classique*, in Montréal, and at the Université de Montréal, Harvard University, and the London School of Economics. One of Canada's most interesting and charismatic political figures, he was a lawyer, a writer, and a controversial leader. He became prime

minister on April 20, 1968, and served until June 3, 1979; he returned to office on March 3, 1980, and retired on June 30, 1984. He founded an important journal of opinion in the 1950s, *Cité Libre*. As prime minister, he repatriated the Canadian Constitution in 1982 and had our Charter of Human Rights enshrined in law. He died in Montréal on September 28, 2000.

W is for Writer. Margaret Laurence was born Margaret Wemyss in Neepawa, Manitoba, on July 18, 1926. Her novels include *This Side Jordan*, *The Stone Angel*, and *The Fire-Dwellers*; her children's books include *The Olden Days Coat*, *Six Darn Crows*, and *The Christmas Birthday Story*. She also wrote the memoir, *Dance on the Earth*. She

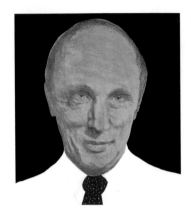

received her BA at the University of Winnipeg, then lived in England and Somalia, before returning to Canada to live in Vancouver. Later she moved to Buckinghamshire in England. She returned to Canada in the 1970s, and lived in Lakefield, Ontario. Once settled in Lakefield, she began to speak and write about issues of concern to her, including the need for immediate nuclear disarmament, the environment, literacy, and other social issues. She won many awards for her books, including the Governor General's Literary Award for *A Jest of God* and *The Diviners*. She also won the Molson Prize in the Arts and was a companion of the Order of Canada. She died on January 5, 1987.

More About the Art

Autumn
BEFORE THE FALL
Acrylic and inkjet on canvas, 2006
24 x 30 in / 60 x 75 cm
Collection of the artist

Alberta
AND WE'LL ALL BE THERE TO
MEET HER WHEN SHE COMES
Lithograph and silkscreen, 1969
24 x 34 in / 60 x 85 cm / ed. 10
Collection: University of Calgary

Butter Tarts
STATE OF THE TARTS
Inkjet on archival matte paper, 2003
12 x 18 in / 30 x 45 cm / ed. 10

Beaver
FUR SURFACING
Acrylic and coloured pencil on
canvas board, 1983
17.5 x 21 in / 44 x 53 cm
Collection: Murray Ball, Toronto

BC
THE MISTOOK NORTH
Inkjet on archival matte paper, 2003
12 x 18 in / 30 x 45 cm

Barns
GREEN BARN, ORO-MEDONTE
Acrylic on canvas, 2003
30 x 40 in / 75 x 100 cm
Collection: Howard Lis, Toronto

GREY BARN, CHARLEVOIX
Acrylic on canvas, 2003
30 x 40 in / 75 x 100 cm
Collection: Minard-Tiffin, Orono,
Ontario

Castle Frank
CASTLE FRANK IN WINTER
Acrylic on canvas, 1984
48 x 36 in / 120 x 90 cm
Collection: Rees Seymour, Toronto

Canoe
SHORELINE
Acrylic and inkjet on canvas, 2003
26 x 40 in / 65 x 100 cm
Collection of the artist

Clouds
CLOUD REFLECTIONS
Inkjet on archival matte paper, 2007
12 x 18 in / 30 x 45 cm / ed. 10

Crossing
MOOSE CROSSING I
Inkjet on archival matte paper, 2007
12 x 18 in / 30 x 45 cm / ed. 10

Ducks
CLIQUE
Acrylic and inkjet on canvas, 2006
32 x 32 in / 80 x 80 cm
Collection: Stanley and Genia Elkind,
Toronto

Dock
DOCK REDUX
Acrylic and inkjet on canvas, 2006
30 x 40 in / 75 x 100 cm
Private Collection, New York

Exploring
MANOE
Acrylic on canvas board, 1983
16 x 20 in / 40 x 50 cm
Collection: Nona Heaslip, Toronto

Elizabeth Simcoe
ELIZABETH SIMCOE AT
CASTLE FRANK
Inkjet and acrylic on canvas,
1984–2007
26 x 40 in / 65 x 100 cm
Collection of the artist

Flags
THE PAINTED FLAG
Acrylic on canvas, 1988
78 x 48 in / 195 x 120 cm
Collection of the artist

THE PAINTED FLAG
Acrylic on canvas, 2002
36 x 72 in / 90 x 180 cm
Collection of the artist

Float
FLOAT
Serigraph, 1986
18 x 30 in / 45 x 75 cm / ed. 10

Flight
FLIGHT
Acrylic on canvas, 2005
30 x 60 in / 75 x 150 cm
Collection of the artist

Glide
GLIDE
Inkjet and acrylic on canvas, 2005
30 x 40 in / 75 x 100 cm
Collection: Delegran, Washington D.C.

Greeting
GREETING
Inkjet on archival matte paper, 2007
16 x 12 in / 40 x 30 cm / ed. 10

Highway
MOOSE CROSSING II
Inkjet on archival matte paper, 2007
12 x 18 in / 30 x 45 cm / ed. 10

Hay Bales
THREE HAY BALES
Acrylic and pastel on canvas, 2004
36 x 48 in / 90 x 120 cm
Collection of the artist

OF THE FIELDS
Acrylic on canvas, 2004
30 x 48 in / 75 x 120 cm
Collection: Dierk Broering, Berlin

Hat
SELF PORTRAIT IN PROVENÇAL
HAT
Acrylic on canvas, 1990
48 x 48 in / 122 x 122 cm
Collection of the artist

Hockey
HOCKEY KNIGHTS IN CANADA/
LES ROIS DE LA REINE
Panels for College Subway Station
mural, Toronto, 1985

Identity
CEREMONIAL
Acrylic and inkjet on canvas, 2006
26 x 40 in / 65 x 100 cm
Collection of the artist

Igloo
ICE HOUSE
Inkjet on archival matte paper, 2007
12 x 16 in / 30 x 40 cm / ed. 10

Joyride
JOY RIDE
Acrylic and pastel on canvas, 1987
46 x 44 in / 116 x 110 cm
Collection: Davies Ward Phillips
Vineberg, Toronto

Judges
THE SUPREMES
Acrylic and coloured pencil on canvas,
1985
42 x 60 in / 106 x 152 cm
Collection: University of Toronto Law
Library

Kite
MOOSE HIGH
Inkjet on archival matte paper, 2008
18 x 12 in / 45 x 30 cm / ed. 10

Kayak
KAYAK
Inkjet on archival matte paper, 2008
12 x 16 in / 30 x 40 cm / ed. 10

Love Pat
LOVE PAT
Inkjet on archival matte paper, 2006
12 x 18 in / 30 x 45 cm / ed. 20
Based on an original painting
40 x 60 in acrylic on canvas
Collection: Linda Schuyler and
Stephen Stohn, Toronto

Landscape
MOOSE ASCENDING
Acrylic on canvas panels, 2005
24 x 72 in / 60 x 180 cm
Collection: Albers-Schönberg, Zurich

Moon
MOOSE LUNAR
Acrylic on canvas, 2005
30 x 24 in / 75 x 60 cm
Private Collection, Toronto

Mounties
ECHELON
Acrylic and coloured pencil on canvas,
1987
36 x 48 in / 90 x 120 cm
Collection of the artist

Mother
MATERNAL
Inkjet and acrylic on canvas, 2006
30 x 26 in / 75 x 65 cm
Collection of the artist

Newfoundland
ARK
Acrylic on canvas, 1999
54 x 72 in / 135 x 180 cm
Collection of the artist

Ojibwa
INVOCATION
Inkjet on archival matte paper, 2006
12 x 18 in / 30 x 45 cm / ed. 10

Picnic
VERGE
Acrylic on canvas, 2004
20 x 40 in / 50 x 100 cm
Collection of the artist

Portrait
SELF PORTRAIT (detail)
Acrylic and coloured pencil on canvas,
1990
60 x 48 in / 150 x 120 cm
Collection of the artist

Poet
PORTRAIT OF MARGARET
ATWOOD
Acrylic and coloured pencil on
canvas, 1980
32 x 28 in / 81 x 70 cm
Collection: Portrait Gallery of Canada,
Ottawa

Queen
DRESSAGE
Acrylic and coloured pencil on canvas,
1988
48 x 36 in / 120 x 90 cm
Collection of the artist

Québec
DRAPEAU DANS LE VENT
Acrylic on canvas, 2001
72 x 48 in / 180 x 120 cm
Collection: Centre d'Art de Baie
St Paul, Québec

Red Barn Reflected
RED BARN REFLECTED
Acrylic on canvas, 2004
36 x 48 in / 90 x 120 cm
Private Collection, Toronto

Simcoe
SIMCOE'S ILLUSION
Acrylic and coloured pencil on canvas,
1993
60 x 60 in / 150 x 150 cm
Collection of the artist

Susanna
PIONEER
Acrylic and coloured pencil on canvas,
1982
48 x 80 in / 122 x 198 cm
Collection: Kalotay, New York

Spotlight
MOOSE SPOT
Acrylic on canvas, 2004
60 x 36 in / 150 x 90 cm
Collection: Linda Schuyler and
Stephen Stohn, Toronto

Side by Side
SIDE BY SIDE
Acrylic on canvas, 2001
36 x 48 in / 90 x 120 cm
Collection: William and Judith
Strachan, Toronto

Pierre Elliott Trudeau
PIERRE BLANC
Acrylic and coloured pencil on canvas,
1990
54 x 54 in / 137 x 137 cm
Collection: Bernadette and Earle
McMaster, Toronto

Tightrope
TOUR DE FORCE II
Acrylic on canvas, 1988
54 x 80 in / 198 x 137 cm
Collection: Davies Ward Phillips
Vineberg, Toronto

Tent
TO ALL IN TENTS/EN TENTE
CORDIALE
Acrylic on canvas, 1986
48 x 72 in / 122 x 182 cm
Collection: The Stratford Shakespearean
Festival, Stratford, Ontario

Trees
BESIDE THE POINT
Acrylic and collaged paper on canvas
board, 1984
16 x 20 in / 40 x 50 cm
Collection: Arlene Perly Rae and Bob
Rae, Toronto

Upside Down
SEALED OFF
Acrylic on canvas, 1986
36 x 54 in / 91 x 137 cm
Collection of the artist

Vacation
INNER HARBOUR
Acrylic on canvas, 1998
60 x 60 in / 150 x 150 cm
Collection of the artist

Winter
BAY WATCH
Inkjet on archival matte paper, 2008
18 x 12 in / 45 x 30 cm / ed. 10

Lake Winnipeg
SHIMMER
Inkjet on canvas, 2007
30 x 40 in / 75 x 100 cm
Collection of the artist

Watching the ducks
REFLECTION
Acrylic and inkjet on canvas, 2006
20 x 30 in / 50 x 75 cm
Private Collection, Toronto

Writer
PORTRAIT OF MARGARET
LAURENCE (detail)
Acrylic and pencil on canvas, 1980
40 x 48 in / 102 x 122 cm
Collection: Avie Bennett, Toronto

X-ray
MOOSERAY
Inkjet on archival matte paper, 2008
18 x 12 in / 45 x 30 cm / ed. 10

Yellow
SUNDANCE
Acrylic and inkjet on canvas, 2006
30 x 40 in / 75 x 100 cm
Private Collection, Muskoka

Zenith
TOUR DE FORCE I
Acrylic on canvas, 1987
48 x 72 in / 122 x 182 cm
Collection: Estate of Bram and Bluma
Appel, Toronto

Loyalist
COLD COMFORT
Acrylic on canvas, 1984
16 x 20 in / 41 x 51 cm
Collection: Dorothy and Keith Davey,
Toronto